Creative Collage

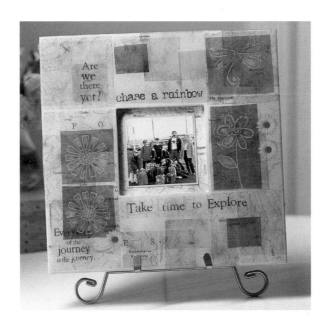

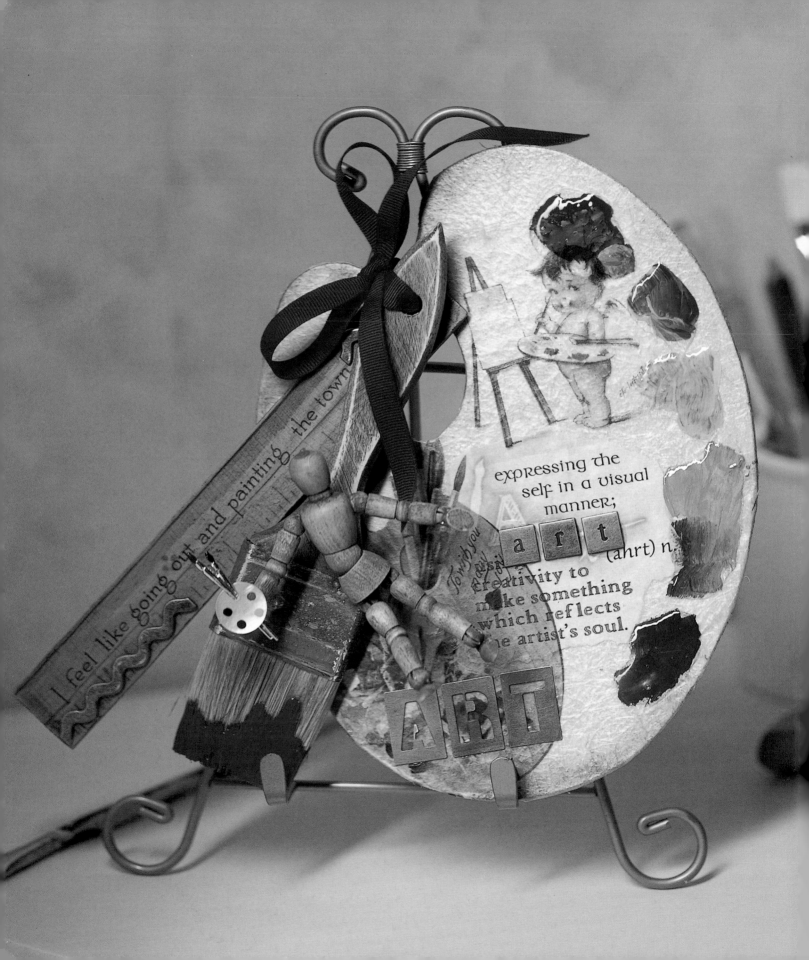

Creative Collage
Making Memories in Mixed Media

MARIE BROWNING

STERLING

New York / London
www.sterlingpublishing.com

Prolific Impressions Production Staff:

Editor in Chief: Mickey Baskett
Copy Editor: Phyllis Mueller
Graphics: Dianne Miller, Karen Turpin
Styling: Lenos Key
Photography: Jerry Mucklow of Rocket Photography, Visions West Photography
Administration: Jim Baskett

Library of Congress Cataloging-in-Publication Data

Browning, Marie.
 Creative collage : making memories in mixed media / Marie Browning.
 p. cm.
 Includes index.
 ISBN-13: 978-1-4027-3509-7
 ISBN-10: 1-4027-3509-X
1. Paper work. 2. Collage. I. Title.

TT870.B7544 2007
736'.98--dc22
 2007015210

2 4 6 8 10 9 7 5 3 1

Published by Sterling Publishing Co., Inc.
387 Park Avenue South, New York, NY 10016
©2008 by Prolific Impressions, Inc.
Distributed in Canada by Sterling Publishing
c/o Canadian Manda Group, 165 Dufferin Street,
Toronto, Ontario, Canada M6K 3H6
Distributed in the United Kingdom by GMC Distribution Services,
Castle Place, 166 High Street, Lewes, East Sussex, England BN7 1XU
Distributed in Australia by Capricorn Link (Australia) Pty. Ltd.
P.O. Box 704, Windsor, NSW 2756, Australia

Printed in China
All rights reserved

ISBN-13: 978-1-4027-3509-7
ISBN-10: 1-4027-3509-X

For information about custom editions, special sales, premium and corporate purchases, please contact Sterling Special Sales Department at 800-805-5489 or specialsales@sterlingpub.com.

Acknowledgments

I thank these manufacturers for their generous contributions of quality products and support in the creation of the projects.

For glues for all surfaces: Beacon Adhesives, Mt. Vernon, NY, USA, www.beaconcreates.com

For embellishments and scrapbook papers: Design Originals, Fort Worth, TX, USA, www.d-originals.com

For copyright free books of images, CD-ROM image collections: Dover Publications, Mineola, NY, USA, www.doverdirect.com

For epoxy casting resin, resin molds, two-part polymer coating (Envirotex-Lite), plastic measuring cups, disposable brushes, stir sticks, thin-bodied "Ultra-Seal" glue: Environmental Technology Inc., Fields Landing, CA, USA, www.eti-usa.com

For cutting tools, Cloud 9 Design decorative papers, and scrapbook embellishments and stickers: Fiskars Brands, Inc., Wausau, WI, USA, www.fiskars.com

For decorative buttons, charms, and beads: Jesse James & Co., Allentown, PA, USA, www.dressitup.com

For decorative papers and scrapbook embellishments and stickers: K & Company, Parkville, MO, USA, www.kandcompany.com

For vintage image books, fabric transfers, and Melissa Frances vintage labels: Heart & Home Inc., Ajax, ON, Canada, www.melissafrances.com

For FolkArt® acrylic paints, Royal Coat® decoupage mediums, decoupage prints, acrylic varnishes, and dimensional varnish: Plaid Enterprises Inc., Norcross, GA, USA, www.plaidonline.com

For walnut ink and stamp pads: Tsukineko Co., Redmond, WA, USA, www.tsukineko.com

For adhesive-backed cotton batik fabric sheets and fabric ribbons: Bali Fabrics, Inc., Sonoma, CA, USA, www.balifab.com

About the Author

MARIE BROWNING

Marie Browning is a consummate craft designer who has made a career of designing products, writing books and articles, and teaching and demonstrating. You may have been charmed by her creative acumen but not been aware of the woman behind it; she has designed stencils, stamps, transfers, and a variety of other product lines for art and craft supply companies. As well as writing numerous books on creative living (with over one million copies currently in print) Marie's articles and designs have appeared in numerous home decor and crafts magazines.

Marie Browning earned a Fine Arts Diploma from Camosun College and attended the University of Victoria. She is a design member of the Crafts and Hobby Association (CHA) and a past board member of the Society of Craft Designers (SCD). In 2004 Marie was selected by *Craftrends* trade publication as a "Top Influential Industry Designer."

She lives, gardens, and crafts on Vancouver Island in Canada. She and her husband Scott have three children: Katelyn, Lena, and Jonathan. Marie can be contacted at www.mariebrowning.com.

Books by Marie Browning Published by Sterling

Paper Crafts Workshop: A Beginner's Guide to Techniques & Projects (2007)
Paper Crafts Workshop: Traditional Card Techniques (2007)
Metal Crafting Workshop (2006)
Casting for Crafters (2006)
Paper Mosaics in an Afternoon (2006)
Snazzy Jars (2006)
Jazzy Gift Baskets (2006)
Purse Pizzazz (2005)
Really Jazzy Jars (2005)
Totally Cool Polymer Clay for Kids (2005)
Totally Cool Soapmaking for Kids (2004 – re-printed in softcover)
Wonderful Wraps (2003 – re-printed in softcover)
Jazzy Jars (2003 – re-printed in softcover)

Designer Soapmaking (2003 – re-printed in German)
300 Recipes for Soap (2002 – re-printed in softcover and in French and Chinese)
Crafting with Vellum and Parchment (2001 – re-printed in softcover as *New Paper Crafts*)
Melt and Pour Soaps (2000 – re-printed in softcover)
Hand Decorating Paper (2000 – re-printed in softcover)
Memory Gifts (2000 – re-printed in soft-cover as *Family Photocrafts*)
Making Glorious Gifts from your Garden (1999 – re-printed in softcover)
Handcrafted Journals, Albums, Scrapbooks & More (1999 – re-printed in softcover)
Beautiful Handmade Natural Soaps (1998 – re-printed in softcover as *Natural Soapmaking*)

Table of Contents

Introduction 8

A Brief History of Collage 9

Chapter 1

A Collage Glossary 10

Chapter 2

Basic Supplies 12

Chapter 3

General Information 17

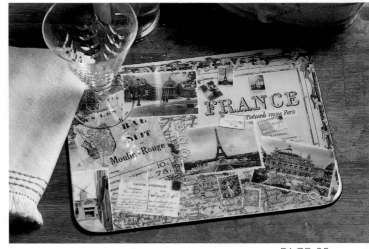

PAGE 85

Chapter 4

Basic Collage Projects 32
Gift of a Garden Greeting Cards 34
Playing the Game Greeting Cards 36
A Fitting Greeting Puzzle Cards 38
A Fitting Gift Puzzle Tags 40
Pretty as a Picture Accordion Photo Card 41
Friends Puzzle Framed Collage 44
Home Sweet Home Framed Mirror 46
Home Sweet Home Paperweight 48
File in Style Mail & Letter File 49
Nature Tiles Coasters 52
Organized Sewing Tin Sewing Box 54
Bold Botanical Serving Tray 56
Live-Love-Laugh Wooden Purse 58

Chapter 5

Miniature Collage Jewelry 60
For a New Mommy Copper Pin 62
French Angel Pendant Necklace 63
Silver Sweetheart Pendant Necklace 64

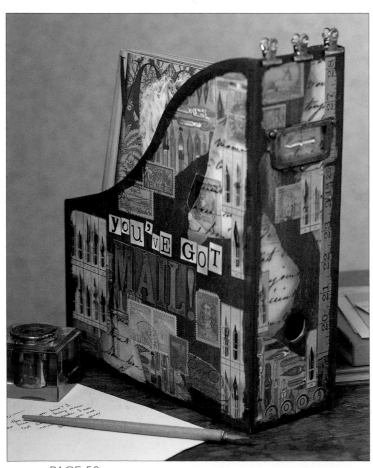

PAGE 50

Chapter 6

ALTERED ART COLLAGE 65
Romance Novel Altered Book 66
Renaissance Pears Display Art 70
Artistic Assemblage Display Art 74
Message on a Bottle Altered Bottles 76

Chapter 7

PHOTO COLLAGE 78
Point No Point Photomontage 80
A Dinner to Remember Photo Placemats 82
Vintage Photos Placemat 83
Sail Day Placemat 84
Postcards from Paris Placemat 85

Chapter 8

BEESWAX COLLAGE 86
Joy Without End Wall Sign 88
Artistic Greetings Decollage Cards 90
Marking the Spot Peat Pots 92
Lavender Fields Candles 94
Art of the Seashore Decorative Tags 96

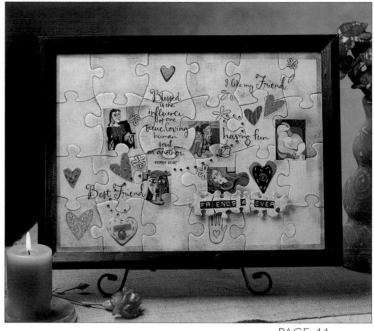

PAGE 44

Chapter 9

TISSUE PAPER COLLAGE 98
Vacation to Remember Photo Frame 102
A Daisy a Day Greeting Cards 104
A Box of Wishes Encouragement Cards 106

Chapter 10

FABRIC COLLAGE 109
Wish You Were Here Vacation Postcards 112
Sisters Framed Collage 114
Pretty Paisley Decorative Box 116
Flowery Collage Gift Tin 119

Chapter 11

CASTING COLLAGE 120
African Safari Paperweight 123
Inspired by Nature Paperweight 124
Good Fortune Paperweight 125
Seaside Sentiments Paperweight 126

METRIC CONVERSION CHART 127
INDEX 127

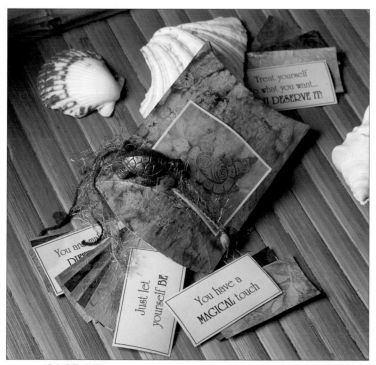

PAGE 106

collages are said to be...

A collage is defined as "a picture or design created by arranging and adhering flat elements such as decorative papers, found paper items, or cloth to a flat surface." Its name is derived from the French word *coller,* meaning "to paste." The process has been widely used by artists such as Pablo Picasso and Romare Bearden and is a familiar technique in contemporary art.

Many of us have childhood memories of creating collages for school or summer camp projects – ripping and cutting out words, photographs, and illustrations from magazine pages and gluing them to create a masterpiece that illuminates a theme. The hodge-podge of images we put together with rubber cement did what fine artists achieved – expressed a message or feeling with images.

Collages are said to be "artistic composition of materials and objects gathered from everyday life"; I like to think that a collage arrangement tells a story about an event, emotion, or color. The scrapbook pages, handmade cards, and artist trading cards (ATCs) we design today fit under this broad definition of collage.

...'artistic compositions of materials and objects gathered from everyday life.'

Most elements in art collages come from "found" materials like images from magazines, newspapers, wallpaper, and paper ephemera such as ticket stubs, labels, postage stamps, and bills (to name just a few). You do not need to be an artist to create a collage – you just need to know simple construction techniques such as cutting, tearing, and gluing.

The most important thing to remember about collage is there are no rules! But trying to achieve the random, artsy quality of artist collages can be overwhelming to beginners. To help take the mystery out of this creative journey, this book shares numerous simple tips and ideas for making many types of collages. We'll explore more specialized collage techniques like beeswax collage, casting, photomontage, altered art, tissue paper collage, and fabric collage. You'll see how to use collage techniques to create a variety of creative cards and tags, decorated containers for storage and gifts, wonderful wall pieces, personalized placemats, terrific tabletop accessories, and charming jewelry pieces.

I encourage you to lose those thoughts about being perfect and measuring exactly, and allow yourself to be creative and unpredictable. When you do, you will be pleasantly surprised at how your other paper crafts projects will improve! Let collage free you and bring out your inner artist.

Marie Browning

A Brief History of Collage

In the early 1900s, Pablo Picasso and Georges Braque glued scraps of printed paper to their painted canvas and charcoal drawings, making collages. This development brought texture and materials other than paint to artwork on canvas. Picasso's *Still Life with Chair Caning*, created in May 1912, is usually considered the first modern collage. Both Picasso and Braque took credit for creating this technique.

Actually, collage has a long history. The earliest examples appear in pre-historic societies where seeds, straw, feathers, and butterfly wings were used as collage materials on masks. Twelfth century Japanese calligraphers pasted bits of paper and fabric to create a decorative surface for their brush strokes. Renaissance artists pasted papers and fabrics into backgrounds of coats of arms; cut-paper silhouettes appeared in The Netherlands in the 17th century. In the 19th century, collage developed into a popular hobby: family photographs, stamps, and postcards were arranged with magazine illustrations and art reproductions in albums. (This, of course, was the birth of the scrapbook, which is a popular art form today.)

Altered Art

A Collage Glossary

As the art of collage grew to become a basic technique for artists, definitions evolved to express the many styles. Here are some definitions and techniques that are associated with the art of collage.

Altered Art

Collage created on a variety of bases that alters the surface with papers and embellishments. Altered art takes collage to an exuberant, creative space where almost everything can be used. The surface altered most often is books – both on the covers and on the pages.

Appropriation

To take possession of another artist's work – often without permission – and reuse it in a context that differs from its original context, most often to examine issues concerning originality or reveal a meaning not seen in the original. An art image used in collage is an example of appropriation.

Assemblage

A collage with three-dimensional objects. Examples of objects used include ribbons, charms, coins, buttons, and beads (collectively referred to as "embellishments"). Assemblages with bulky embellishments are called relief sculptures.

ATC (Artist Trading Cards)

Miniature works of art on 2½" x 3½" pieces of card stock that are traded in person or by mail. ATCs are never sold and can include all types of art techniques. Collage is a method often utilized.

Beeswax Collage

A relatively new technique where all the collage elements, including embellishments, are adhered to a rigid surface with melted beeswax.

Bricolage

An improvised creation made from whatever materials happen to be available. From the French *bricole,* meaning a trifle; possibly related to the term "bric-a-brac."

Beeswax Collage

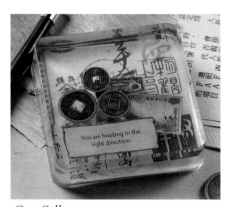

Cast Collage

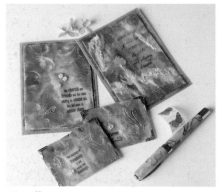

Decollage

Cast Collage

A collage created in a mold and preserved in plastic resin. It forms a three-dimensional casting such as a paperweight, penholder, or decorative sculpture.

Decollage

French for "take-off" or "become unstuck," decollage is the opposite of collage. Instead of creating an image by layering, it is created by cutting or tearing and removing pieces of an image. Examples can be seen in the work of 20th century artist Romare Bearden, who used sandpaper to distress and remove images on his collage pieces.

Decoupage

The technique of decorating surfaces by adhering cutouts, most commonly of paper, and coating them with one or more coats of a transparent or translucent finish, such as decoupage medium or, more traditionally, lacquer or varnish.

Femmage

A collage that includes textile art traditionally produced by women.

Mixed Media

An art object that incorporates more than one medium – for example, a beeswax collage with papers, feathers, charms, and ribbons.

Montage

A collage that incorporates photographs.

Nature Collage

A collage made up of items collected from nature, such as pressed flowers or leaves and handmade papers.

Papier-colle

A type of collage in which paper shapes are glued to a base and then painted. This French term literally means "stuck paper."

Photomontage

A collage made entirely from photographs or parts of photographs.

Tissue Collage

A collage technique using layers of tissue paper to create a design. Tissue collage can be combined with other collage and decoupage techniques.

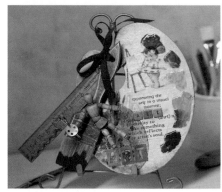

Mixed Media

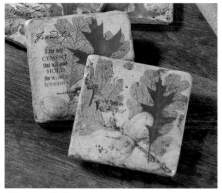

Nature Collage

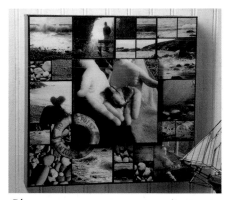

Photomontage

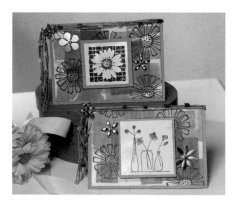

Tissue Collage

Basic Supplies & Tools

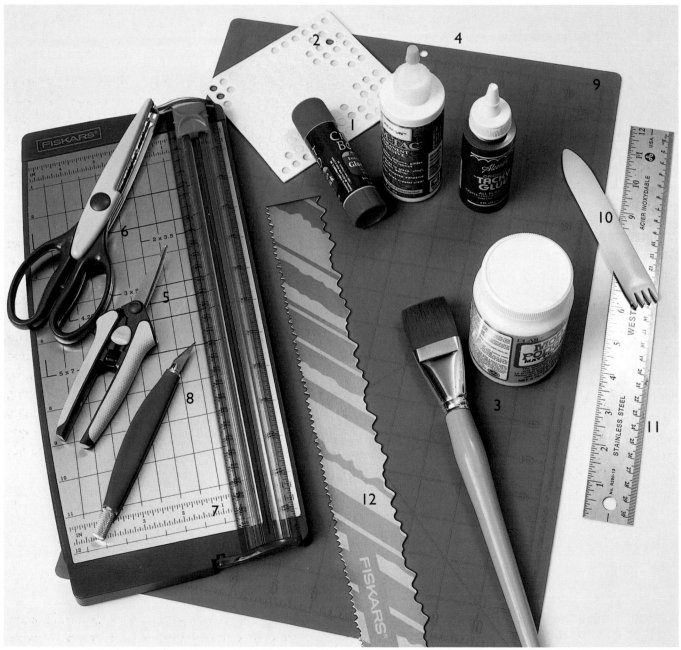

Pictured above: 1)Glue stick; 2)Glue dots; 3)Decoupage medium and Brush; 4) Craft glue; 5) Scissors; 6) Decorative edge scissors; 7) Paper trimmer; 8) Art knife; 9) Cutting mat; 10) Bone folder; 11) Ruler; 12) Deckle edge ruler

Bases

The base is the surface on which you create your collage. It can be anything from a card blank to a bottle or a book cover. Bases used for the collage projects in this book include more traditional, flat surfaces such as card blanks, wooden frames, plates and files, marble tiles, jewelry bezels, table mats, and metal boxes. Other more unusual bases for the collage projects include candles, artificial pears, artist's palettes, and even garden peat pots.

Adhesives

The base you use and your chosen collage elements determine the type of adhesive or glue for attaching the collage elements. Here are some guidelines:

Glue stick
For paper bases, such as card blanks, a glue stick works well. When working with a glue stick, work on a gluing sheet to keep the fronts of your images free of excess glue. Wax paper, deli sheets, or pages of an old phone book make good gluing sheets.

Glue dots
Glue dots raise a paper image or embellishment off the surface and give a layered effect to a collage. Glue dots are available in a variety of sizes, from very tiny (⅛") to larger (½") in both round and square shapes. Some glue dots are thin pieces of foam with adhesive on both sides; others are dimensional clear dots of glue on a protective paper roll.

Decoupage medium
On wood or canvas bases, use decoupage medium to glue papers. Regular (podge-type) decoupage mediums come in a variety of finishes, including gloss, satin, matte, sepia-toned, and pearl. Apply them to the back of the paper pieces with a ½" to 1" brush.

Craft glue
Thick, tacky white craft glue is used for adhering heavier embellishments and creates a much stronger bond than hot glue. Specialty craft glues, such as jewelry and wood glues, work better for specific applications, such as jewelry glue for adding embellishments to a metal surface. These glues are white when wet and dry crystal clear.

Thin-bodied white glue
Thin-bodied white glue can be used to attach paper pieces to surfaces. It goes on white and dries crystal clear. Because it contains latex, thin-bodied white glue is used to seal paper pieces before applying a polymer coating. This seal coat prevents the resin from bleeding onto the paper and leaving dark spots. It's best to apply two thin coats rather than one heavy coat; make sure the first coat has dried before brushing on the second coat, and be sure the seal coat is totally dry and clear before applying the polymer coating. If the glue is just a little bit damp, it will turn white under the coating and ruin the design. **Do not** substitute a decoupage medium – most do not contain enough latex to seal the paper properly.

Basic Tools

Scissors
For many cutting jobs, a basic pair of straight edge scissors works well. *Decorative edge scissors* give a variety of different edges to designs.

Paper trimmer
A paper trimmer can cut squares, rectangles, and borders from decorative papers. I prefer the slide-type of trimmer, which is readily available at craft and art stores.

Continued on next page

Basic Tools, continued

Art knife or craft knife

An art knife with a #11 blade is used to cut papers that cannot go through a paper trimmer, such as fine tissues or heavily textured handmade paper, and for cutting out the inside areas of images. Always cut on a **self-healing cutting mat** to protect your work surface.

Bone folder

A bone folder is an indispensable tool for creasing folds in paper. You can also use its smooth sides to press down paper pieces when adhering them to surfaces (A process called "burnishing") to remove wrinkles and creases quickly and create a firm bond.

Ruler

Though a ruler is rarely used when creating a collage, the edge is handy for tearing a straight edge. Choose a metal ruler with a cork backing for best results. Use **decorative edge rulers** to create decorative torn edges for your designs.

Paper Images

Just about any printed paper image can be used to make collages – both thin and thick, glossy or dull, smooth or textured, plain or patterned, and colored, tinted, or black and white. You can use handmade paper, decoupage paper, and colored tissue, to name a few. Paper images can be obtained from an infinite number of sources, including photographs, magazines, scrapbook papers, paper napkins, greeting cards, and wallpaper – all are excellent sources of images.

Ephemera

Collage artists especially prize ephemera, the name given to pieces of paper from everyday life. You can find vintage ephemera printed on scrapbook paper or at second-hand or antiques stores. Whole books offering one-sided pages of interesting ephemera are found at craft and scrap-booking stores ready for you to cut and use.

Popular paper design elements include handwritten love letters, pages from old books, old documents, and everyday items such as tickets, labels, and certificates. Don't neglect to check your own attic or filing cabinet for ephemera such as old letters, postcards, and family records. If you don't want to use a precious or one-of-a-kind item or image, color photocopy or scan and print it for the collage. **Always** copy valuable pieces and use them rather than including the original in your project.

Decorative papers

Decorative papers are available in a huge assortment of colors, designs, and textures. In just one walk around a scrapbooking, crafts, or art supply store, you will discover many papers that inspire your need to create. Different types of decorative papers can be used in collages, from thin tissue papers, wrapping paper, and handmade papers to the heavier card stock memory papers and art prints.

Decoupage papers

Decoupage papers provide a huge selection of beautiful papers. New to the market, lightweight tissue-like decoupage papers are especially wonderful for layering and as additions to beeswax collages.

Image collections

Collage is a derivative work that often incorporates elements of other works, and a concern for collage artists is the use of copyrighted images. Copyright law can be confusing, but there are many sources of beautiful images that can be used without fear of infringing on someone else's copyright. Scrapbooking, rubber stamping, and crafts stores sell paper image collections intended for collage work in both color and black and white. Information provided with the collections details what constitutes proper use of the collection (typically the free use of 10 images from each book per collage).

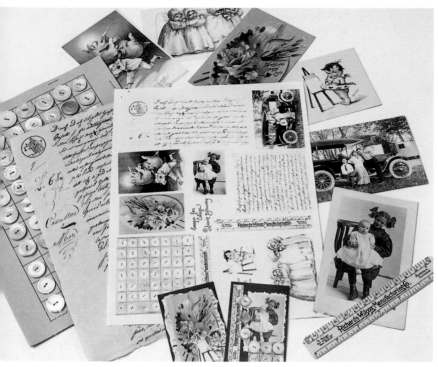

Pictured above: A color-photocopied sheet is surrounded with various examples of ephemera and flat objects that can be scanned or photocopied. On top of the photocopied sheet are two artist trading collage cards created with the images.

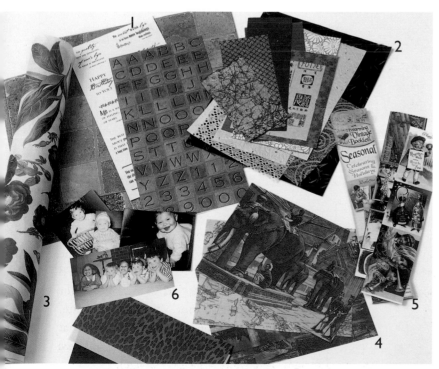

Pictured above – Paper Images for Collages: 1) Decorative papers with matching stickers and vellum sayings; 2) Handmade papers; 3) Decoupage papers; 4) Collage image collections; 5) Vintage image booklets; 6) Photographs

Decorative Elements

Stickers

Stickers offer an instant piece of artwork that you simply peel and stick on your composition. For planning, it's a good idea to roughly cut out the sticker, leaving the backing paper in place until you are ready to permanently attach the sticker. I especially like to use sticker alphabets, and I always keep the leftover letters when I finish a project. Mixing and matching the different letters can create visual interest on a collage. Look also for fine art stickers, vintage labels, and quotes printed on vellum.

Embellishments

Found items

Found items most likely already in your home include coins, corks, keys, and buttons. Raid your sewing room for pieces of fabric, ribbons, cords, and lace to add texture and interest.

Natural materials

Natural materials include shells, pine cones, pebbles, dried flowers, feathers, dried leaves, skeleton leaves, coral, sand, and natural papers.

Decorative embellishments

Items from crafts and paper crafting stores include charms, silk flowers, clock parts, beads, tags, eye-

Storing Your Supplies

When you have collected papers and items for your collage, you will need an easily accessible system for storing them. I like to store the bits and pieces in zipper-top bags that I place in large plastic containers. This enables me to see all the materials without having them all cluttered together. Sophisticated storage systems for everything from small collections to larger bins are available. You can sort by color, by theme, or by type of material.

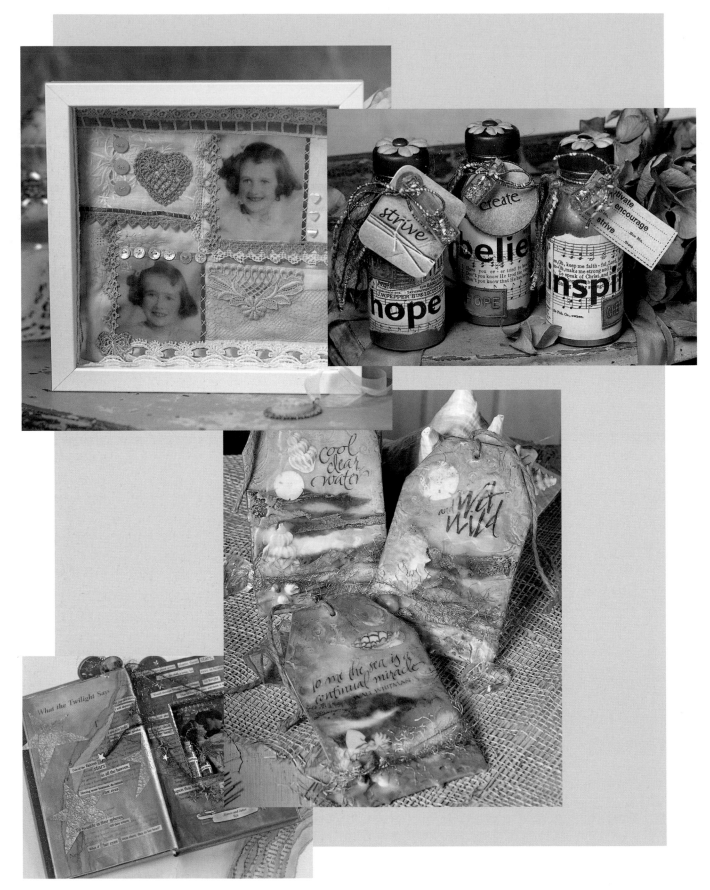

General Information

When you create a collage, there are no rules or limitations –
you have the freedom to create with just about anything! This freedom
brings its own questions and quandaries: How do I begin?
What items work best? When will I know when it's finished?
These and many more topics are discussed in this chapter, along with
tips and collage techniques to help you get started.

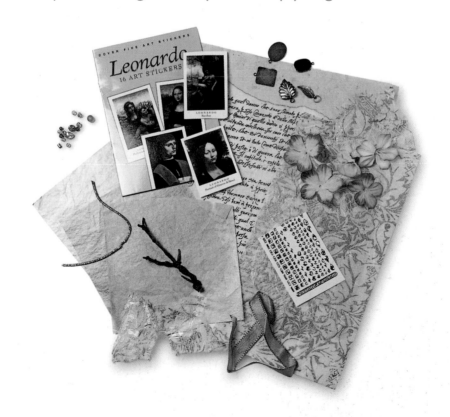

Designing Your Collage

Whether your collage is large or small, complicated or simple, the basic steps for creating it are the same. When you're just starting out, start small. Begin with a small-size project, such as a greeting card.

The Basic Steps

1. **Choose a theme.** It can be anything! Abstract compositions work with colors and shapes; realistic compositions work with a subject or concept. The theme can be a color, a mood, an emotion, an event, or a place, person, or thing. It can be as simple as "blue" or more complicated like "travel to Paris."

2. **Gather your materials.** Think of images, colors, photographs, texture and ephemera that relate to your chosen theme, and gather materials. Use quotes, words, or letters to help communicate the theme.

3. **Choose a focal point.** A focal point helps direct the eye into the composition; it can be a photo, a larger or contrasting image, or a word or a quotation. Consider framing this piece by placing a piece of contrasting paper behind it or by edging the piece with a colored, inked edge.

4. **Plan the layout.** Lay out the pieces without gluing them to try different arrangements. Don't start gluing until you are happy with how the pieces look. Here are some guidelines:
 - Place the background pieces and larger pieces first.
 - Cluster embellishments or small paper images in odd numbers (e.g., one, three, or five).
 - Vertical and horizontal lines are more "quiet"; diagonal lines bring movement.
 - Use a variety of effects, e.g., rip some paper edges, cut others.
 - Allow yourself to be impulsive.
 - Squint at the composition to see if you have achieved a balance with tones of color.

5. **Re-evaluate.** When you think you are finished, step away for a while, then come back and re-evaluate the composition. Turn it upside down or sideways for a different perspective. Introduce a new element for contrast. Decide what looks good to you. Trust your instincts.

6. **Glue.** When – and only when – you are happy with the arrangement, start gluing the pieces.

Elements of Design

All collages follow basic design elements – line, shape, color, texture, and composition. Considering the elements of design helps answer your questions: Why does my eye flow smoothly around the collage? Is the collage too busy? Why do I not like the end design? It is you, the artist, who combines and balances these elements to create the finished piece. After a while you will find you become more insightful about these design considerations. What follows is a greatly simplified discussion of the five elements. (If this seems like too many rules, think of design considerations as tools that can help you when you are stuck. Sometimes you need to ignore the rules and play.)

Line

Lines define the borders of your collage – where it starts and ends. Within the collage, you can incorporate straight or curved lines. They can be horizontal, vertical, curved, or diagonal.

Shapes

Shapes are hidden in all collages. They can be circles, squares, rectangles, or triangles. They can have clean, cut edges or torn, rough edges. With shapes come patterns.

Visual patterns give dimension to your collage when you mix different sizes of shapes or repeat shapes. Shapes are found in individual motifs and in clusters of motifs that create both positive and negative shapes in your collage.

Color

The four characteristics of color are hue, temperature, value, and intensity. The hue is the name of the color; such as "teal" or "green-blue." The temperature of a color refers to whether it is hot or cool; for example, orange-red is a warm red, and blue-red is a cool red. Value is the expression of light and dark, such as pale blue or dark blue. Intensity refers to whether a color is bright or muted. A pure yellow is bright, for example, while ochre, a muted yellow, contains a touch of a complementary color (purple) that mutes it.

Texture

Contrasting textures make a more interesting collage, such as smooth vs. rough or shiny vs. dull.

Composition

Composition is how the elements of a design are arranged and considers the focal point, movement, and balance.

Focal point

A focal point grabs the viewer's interest and helps to retain that interest. Every collage needs at least one center or area of interest. If there is more than one focal point, one of them must dominate. The focal point is what makes great works of art so compelling.

The Rule of Thirds is a great way to find where to place a focal point. Divide the design into three vertical and three horizontal sections, like a tic-tac-toe grid. The areas where the lines intersect are the most pleasing areas to place a focal point, the so-called sweet spots. Here are some examples:
• Eyes and faces
• People and figures
• Words, numbers, and symbols
• Manmade objects
• Contrast, such as light against dark, small against big
• Sharp edges
• Bright, pure colors
• Anomalies (something different, unusual, out of the ordinary)

Movement

Movement is how your eye travels through the design. Repeating motifs, colors, shapes, or textures in your composition brings rhythm and pattern to the collage. Repetition creates movement to direct the eye and fosters unity. Diagonal lines bring movement to a design, while vertical and horizontal lines are quiet.

Balance

Balance gives the sense that all the elements belong and work together. Your collage should be seen as a unified whole, not as parts thrown on a base. Balance can be achieved by not overwhelming your surface with too many shapes, lines, colors, or textures.

Balance means to equalize the weight (importance) of the elements of design. In formal balance, all the parts of the collage are of equal weight and are placed symmetrically. Informal balance can be achieved when you vary the value, shape, size, and location of the collage elements, often asymmetrically. Symmetry creates a calm atmosphere. Asymmetry is a little busier. A collage that's too busy doesn't have balance or harmony.

To balance color in a collage, you could use warm tones (terra cotta red and moss green) of two contrasting colors (red and green). Colors can be balanced by their value (e.g., by using all pastels). Balance can also be achieved by using all muted colors with a bright color as a focal point (for example, a collage made with muted browns and greens could have one bright red element as a focal point).

Preparing the Base

A properly prepared base provides the foundation for your collage. Here are some examples of ways to finish your surface before adding your collage.

Coating with Gesso

Acrylic gesso is a paint product (usually white, but available in other colors) that is used as a primer on plastic, canvas, metal, or paper surfaces. When dry, gesso provides a stable, matte surface for a collage. Gesso does not soak into wood or paper surfaces and usually covers in one coat.

Here's how:
1. Shake the gesso container to mix.
2. Apply gesso to surface with a sponge brush or natural bristle brush. Let dry, then decide if you need a second coat.

Basecoating with Paint

Proper basecoating ensures a smooth painted finish on wood that is trouble-free. To prepare for painting, remove any hardware.

Here's how:
1. If your wood surface has knots or dark patches, seal them with an acrylic sealer before applying the paint. Let the sealant dry completely before proceeding.
2. Apply the first coat of acrylic color with a large basecoating brush to evenly coat the surface with paint. Let dry completely.
3. Sand the painted surface well with medium (100 grit) sandpaper. (The moisture in acrylic paint raises the grain of wood, and sanding smooths the surface.) Wipe away the sanding dust.
4. Apply a second coat of paint on top of the first.
5. If needed, add a third coat of paint. Your goal is even coverage with no patches or brush marks.

Old Painted Wood Look

This technique creates the look of old painted wood that has naturally weathered over time and developed an interesting patina. Wax is used as a resist under the paint to make sanding easier. Apply one coat for a distressed finish or up to three different colors of paint for an old painted wood finish.

Here's how:
1. Rub a piece of uncolored wax (an old candle works well) on the wood surface in areas where it would normally show wear, such as the edges.
2. Apply the paint in a single coat over the entire surface, including the waxed areas, and let dry.
3. If you're using more than one color, rub more wax over the first layer of paint, then add a second paint color.
4. Continue to layer wax and paint, allowing each coat of paint to dry completely.
5. When the final coat of paint is dry, sand the entire piece to reveal the original wood surface plus all the different layers of paint.

Decoupaged Surface

Covering a base with paper provides a decorative surface for your collage.

Here's how:
1. Cut the paper approximately ½" larger than the surface you are covering.
2. Place it right side down on your work surface. Using a large brush, apply a thin layer of decoupage medium or thin white glue to the back of the paper.
3. Immediately place the paper on the base and, working from the center, smooth out any air bubbles or wrinkles with your hand or a bone folder. Let the glue dry completely.
4. Sand the edges to remove the excess paper and leave a perfect edge.

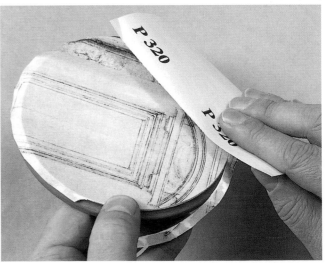

Sanding the edge of the paper so it fits perfectly on the base.

Enhancing Metal Embellishments

On metal pieces and metal items such as charms, I like to use paint to create a weathered look. I prefer acrylic paints – the kind designed for use on metal – to chemical products that actually rust and age the metal. Although chemical products give a more authentic aged look, I find I have more control with paint. Here are my favorites.

Distressed Metal

Painting, then sanding gives a worn look. You can sand a little or a lot, depending on the look you wish to achieve.

Here's how:
1. Rub the metal surface with an alcohol wipe and let dry.
2. Brush on two to three coats of metal paint, letting the paint dry between coats.
3. When the final coat is completely dry and cured, sand the surface lightly with 300-grit sandpaper.
4. Use a fine abrasive pad to refine the look and remove any scratches from the exposed metal.

Washed Metal

This painted finish adds subtle color that helps highlight embossed designs and give a look of metal that became faded and dull over time.

Here's how:
1. Rub the metal surface with an alcohol wipe and let dry.
2. Brush on a thin coat of metal paint.
3. Wipe off some of the paint immediately with a soft cloth or paper towel. If you remove too much paint, repeat the steps until you achieve the look you wish. *Option:* When dry, refine further by rubbing with a fine abrasive pad.

Rusted Metal

This technique gives metal an old, rusty look. Using a sponge imparts a slightly bubbled texture.

Here's how:
1. Rub the metal surface with an alcohol wipe and let dry.
2. Apply a coat of burnt sienna metal paint with a painting sponge.
3. Sponge on some patches of dark brown metal paint. You can add them while the first coat is still wet; the colors will blend nicely. Let the paint completely dry and cure.
4. Add a little turquoise metallic wax to some areas for an authentic-looking finishing touch. (This accents the embossed areas and the paint texture.)

Verdigris Patina

This gives copper a naturally aged look.

Here's how:
1. Rub the metal surface with an alcohol wipe and let dry.
2. Brush on a coat of dark brown metal paint.
3. Immediately wipe off some of the paint with a soft cloth or paper towel. Let dry.
4. Sand lightly to restore the sheen of the copper.
5. Finally, apply turquoise metallic wax over much of the surface, allowing areas of copper and brown paint to show.

Working with Paper

Here are some of the techniques I use for preparing and adding texture and interest to paper pieces.

Cutting Out Motifs

Use this technique to create perfect cutouts.

Here's how:

1. Trim away excess paper around the motif.
2. Use an art knife and a cutting mat to cut out inside areas before cutting around the outer edge.
3. Use small, sharp, pointed scissors to cut out the design. Hold the scissors at a 45-degree angle to cut the paper with a tiny beveled edge – this helps the motif to adhere snugly against the surface. Move the paper, not the scissors, as you cut.

Tearing

There are several techniques for tearing paper pieces. Torn paper pieces without white edges will blend into the composition. To tear a piece of paper without a white edge, rip away from you. Torn paper pieces with white edges will frame the torn piece and make it stand out. To tear a piece of paper with a white edge, rip towards you.

Here's how:

1. To tear a straight edge, place a ruler on the paper where you want to tear it.
2. Using a brush with clean water, brush a line of water on the paper, using the ruler as a guide.
3. Place the ruler on the water line and tear carefully. You also can use the water line technique to tear shapes and wavy lines.

Crumpling

Crumpling creates fine creases over the entire piece of paper. For an antique look, apply a tea or coffee stain after crumpling.

Here's how:

1. Carefully crumple the paper with your hands, un-crumple, then crumple again. The more you crumple it, the more aged it will look.
2. Un-crumple the paper and smooth it to flatten.
3. For a more polished look, iron the paper. Set the iron to medium-high, and don't use steam.

Sanding

Use fine sandpaper or emery boards to lightly sand and distress the paper pieces.

Here's how: Rub the paper just a little or a lot (your choice) with a piece of 300-grit sandpaper or an emery board. To create a sanded design on the paper, place the paper piece right side up over a texture plate, then sand to reveal the texture on the front of the paper.

Antiquing Paper with Coffee & Tea

Strong solutions of tea or coffee can be used to soak and antique papers and fabrics. This solution can also be brushed on or spattered for interesting effects. You can iron papers to flatten them after antiquing – use a dry iron (no steam) and medium-high heat and iron directly on the paper. If you use decoupage medium to glue the paper to the surface, you don't need to iron it smooth.

Here's how to antique with tea

Various tea blends offer different colors; for example, berry-based herb tea is pinkish, and orange pekoe tea

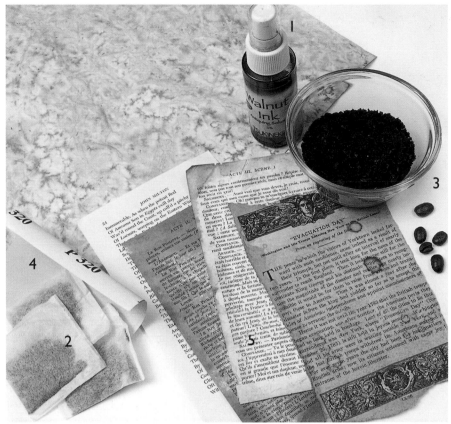

Pictured above – Materials for distressing paper and examples: 1) Walnut ink, 2) Tea, 3) Coffee, 4) Sandpaper, 5) Samples of papers.

Ink Antiquing

Use ink all over paper pieces or just on the edges for an antique look.

Walnut ink can be applied by brushing, spraying, spattering, or stippling. Walnut ink is available in crystal or liquid form. I prefer the liquid that comes in a handy spray bottle – you can brush or spatter the solution or spray it on.

Or use a **sepia or dark brown inkpad** and a stencil brush. Load the brush by tapping it on the inkpad, then use small circular strokes to apply the ink to the edges of the paper. Use several light layers to build the intensity and avoid blotches.

Chalk Coloring

Use chalk to create aged highlights and subtle tints of color on line art. For an aged look, use ochre, brown, rust, black, or moss green. I like to use small foam applicators (the type used to apply powdered makeup). Lightly rub chalk over the paper. Keep adding light layers of color until you are happy with the results.

Metallic Highlights

Metallic wax can be applied to a variety of surfaces for gleaming, shimmering highlights. It's especially nice on paper pieces. Apply with your finger and buff when dry. You can also use the wax to add a soft metallic gleam to papers that have been coated with decoupage medium or beeswax.

offers an orange-sepia hue. The tone you get depends on the strength of the tea solution and the length of time the paper is soaked.

1. Place 5 tea bags in 1 cup of boiling water and let brew until cool.
2. Place the paper on wax paper and use a cooled tea bag to sponge the solution directly on the paper. Dilute the strength of the color by spraying with clear water.
3. For a mottled effect, sprinkle brewed tea leaves on the wet surface. Do not disturb until completely dry.

Here's how to antique with coffee:

Coffee tints the paper a soft tan or beige color, depending on the type of paper.

1. Place 2 Tablespoons instant coffee in ½ cup boiling water, stir, and let cool.
2. Place the paper on wax paper. Brush or spatter the coffee solution (full strength or diluted) over the paper.
3. For a mottled effect, sprinkle the grounds from brewed coffee or instant coffee crystals on the wet paper. Do not disturb until completely dry.

Gluing Techniques

Before you glue, arrange your composition and move the pieces around to try different arrangements. When you are happy with how things look, permanently adhere them to the surface. Use freezer paper or wax paper to protect your work surface when using glues.

Recommended Glues

Glue stick, for gluing paper to paper

Decoupage medium, for adhering paper to wood, metal, or canvas

All-purpose white craft glue, to secure heavier items like embellishments, fabric, or ribbon to any surface.

Gluing Medium Weight Papers

Here's how:

1. Lightly coat the back of the paper with decoupage medium or thin-bodied glue, working from the center of the paper piece outward, making sure you have glue on all the edges.
 - Larger paper pieces are the most likely to bubble and wrinkle; it's important to work fast and be sure to evenly coat the paper with glue.
 - Using too much glue will cause excessive wrinkling that cannot be corrected.
2. Lift the paper piece and position in place.
3. Using your fingers, carefully smooth the image with your fingers to remove wrinkles and bubbles. (You can use a bone folder if you are working on a paper base.)
4. Let the glue dry before proceeding.

Glue Fine Papers

For papers such as tissue and fine handmade papers, brush decoupage medium on the surface, then attach the paper piece. Immediately brush more decoupage medium over the paper to adhere and smooth out any wrinkles.

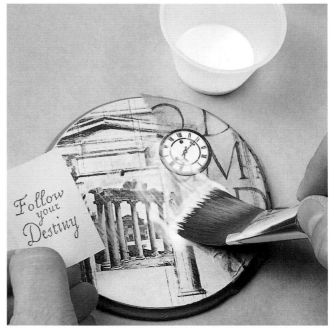

Using decoupage medium to adhere paper elements.

Layering

Overlap and layer paper pieces to create interesting backgrounds, such as a photograph placed over a letter, or to build up textures for dimension. For best results without bulk, use thinner papers such as handmade papers, the printed or colored layers of paper napkins, and tissue papers. Heavier papers can be layered for added thickness.

Using & Creating Transparencies

Layering transparent images adds richness and depth to your collage. You can purchase images printed on clear sheets especially designed for creating collages or use stickers with clear and translucent backings. Transparencies are most effective on light colored backgrounds that are not too busy. Apply them to your collage with spray adhesive or decoupage medium, stitch them in place, or use brads, eyelets, staples, or paper clips to attach them.

Photocopied Transparencies

Simply color photocopy or laser print images on transparency film or light-colored vellum.

A color photograph was photocopied onto transparency film over a letter background.

A color photograph photocopied onto vellum.

Transparent Stickers

These stickers, which are quotations on a clear backing, couldn't be easier to use. Just peel, position, and stick.

Legacy \leg-a-cy\ *n, pl.* **–cies** 1. money or property that is left to somebody in a will 2. something that is handed down or remains from a previous generation or time

THE FAMILY IS ONE OF NATURE'S MASTERPIECES.
George Santayana

Using & Creating Transparencies, continued

Decal Transfer Film

Decal film enables you to color photocopy an image on a sheet. The decal can be permanently applied to many types of surfaces, including fabric, metal, stone, glass, wood, and paper and over paint. You simply soak the decal in water and slide it on your surface. Because the film is thin, it works well for rough or highly textured surfaces. Follow the package instructions for photocopying and applying the transfer to your chosen surface. (You don't need to reverse the image.)

Purchased Transparencies

You can buy transparencies at scrapbook shops like this black line image on clear film. Typically these transparencies don't come with adhesive.

Contact Paper Transparencies

Try this simple, inexpensive method that uses clear self-adhesive paper for making transparencies. Images with a dark background are semi-translucent; images with a light background are more transparent and allow more of the background to show. You do not need to reverse the image for this technique. Use decoupage medium to adhere the transparency to the collage.

You'll need:
• Clear self-adhesive paper (You can also use a laminating sheet or clear packing tape.)

• A printed image (You can also use an image printed with a color copier. There is no need to reverse the image. Note: Images printed on an inkjet printer won't work.

• Bone folder

• Bowl of warm water

Music sheet transparency/ original image/ decorative paper for backing

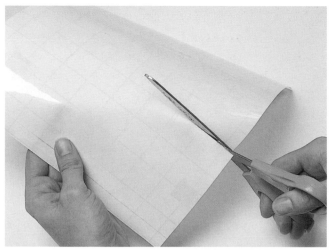

1. Cut the self-adhesive paper to the same size as your image.

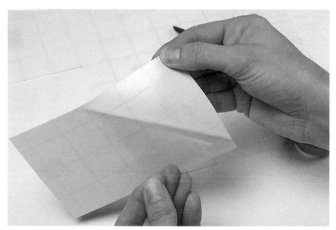

2. Peel off the protective paper backing.

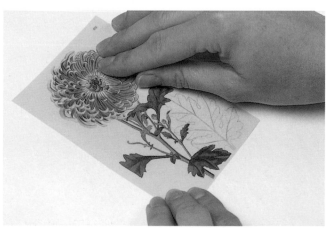

3. Press the sticky side of the self-adhesive paper to the image. Burnish the surface well with a bone folder to make sure the image makes full contact with the self-adhesive paper.

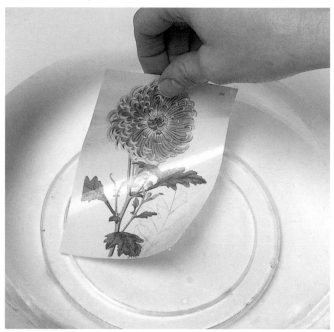

4. Soak the image in a bowl of warm, clean water for about 10 minutes. The heavier the paper, the longer you need to soak it.

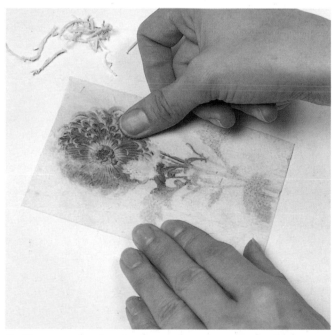

5. Remove the image from the water and place on a hard, clean surface, such as a kitchen counter. Gently rub the back of the paper with your fingers, removing the paper but leaving the image on the clear film. Let dry. (When dry, it will be semi-transparent.) If you see some paper remains, simply re-soak to wet the paper and rub gently to remove it.

Examples of Contact Paper Transparencies:

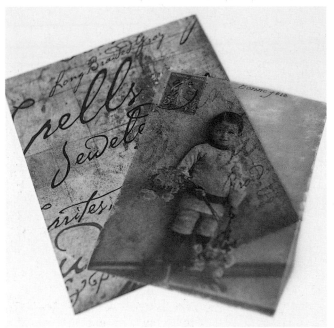

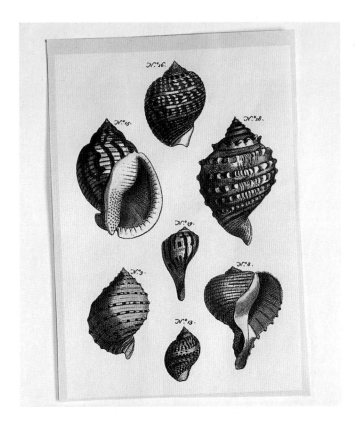

Young boy transparency/ decorative paper for backing – dark background image on dark background

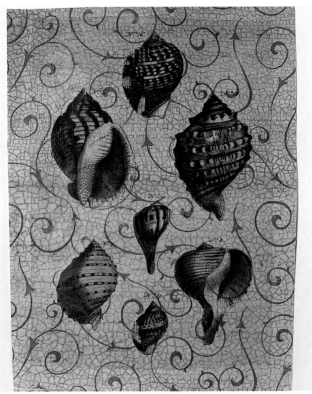

Lady transparency/ decorative paper for backing – dark background image on light background]

Shells transparency/ original image/ decorative paper for backing

Protecting Your Collage

Properly protecting your finished work ensures it will last for years of enjoyment.

Acrylic Varnish

On painted surfaces, apply two or three coats of acrylic varnish to protect and beautify the finish. Acrylic varnishes come in gloss, satin, and matte sheens as well as sepia, metallic, and iridescent tones.

Here's how:
1. Roll the varnish container to mix – don't shake it – to minimize the appearance of bubbles on your finished piece.
2. Pour the varnish in a small disposable bowl. (This prevents the large container from being contaminated.)
3. Use a large soft brush to apply the varnish to the surface in slow, thin coats. Let each coat dry thoroughly before adding another layer of varnish. The more thin coats you apply, the tougher the surface will be.

CARE: To care for a varnished surface, simply wipe with a damp cloth. For tough stains or marks, gently sand with very fine grit sandpaper until the mark is gone. Re-varnish the piece with at least two coats.

Dimensional Varnish

This product is the answer when you want a shiny, dimensional paper piece without using a polymer coating. It comes in a handy bottle with a narrow opening for squeezing the varnish onto individual paper pieces. It dries clear with a slight dimension. It is available in clear, sepia, and antique hues as well as clear crackle.

Here's how:
1. After the paper pieces are decoupaged to the surface, apply a topcoat of decoupage medium.
2. When dry, squeeze dimensional varnish onto each paper piece, being careful not to let the varnish flow off. (TIP: Outline each piece, then fill in.) Let dry undisturbed.

Peeling Paint Look

Petroleum jelly and paint are used to create a vintage effect on collages after the collage is completed. The petroleum jelly is used as a resist; paint peels off easily where the resist was applied.

Here's how:
1. After you finish gluing the collage elements and the glue has dried, apply two to three coats of acrylic varnish. Let each coat dry completely before applying the next one.
2. Rub a thin coat of petroleum jelly over some areas of the collage where you want the paint to peel.
3. Brush on one coat of acrylic paint. Let dry thoroughly.
4. Rub off the paint with a soft cloth from the areas where the petroleum jelly was applied to create the antique effect.

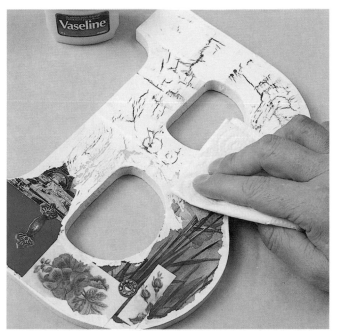
Rubbing off paint applied over a petroleum jelly resist to reveal the collage.

Continued on next page

Protecting Your Collage, continued

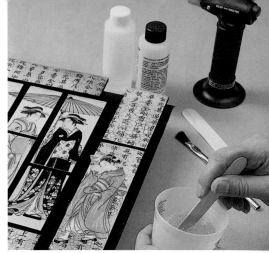

Polymer Coating

A polymer coating is liquid plastic that can be poured on a variety of surfaces and cures to provide a thick, permanent, waterproof, high gloss surface. The coating comes in two parts, a resin and a hardener. When equal parts are mixed together they react chemically to form the polymer coating.

For best results, work in a dust-free room with a temperature of 75 to 80 degrees F. and humidity under 50 percent. When cured, polymer coating is chemically inert and completely machineable, so you can easily drill or sand it.

Photo 1

BASIC SUPPLIES for Polymer Coating

Two-part pour-on polymer coating

Plastic mixing cup with accurate measurement marks (Disposable plastic cups with amounts printed on them are sold alongside the coating.)

Wooden stir stick

Disposable glue brush

Freezer paper or wax paper

Clear cellophane tape

Sandpaper

Thin-bodied white glue

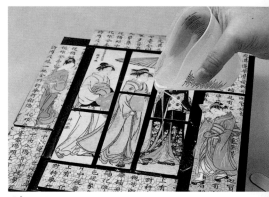

Photo 2

BASIC INSTRUCTIONS for Applying a Polymer Coating

1. **Seal the project.** Seal the paper with two thin coats of white glue before coating. If paper is not sealed properly, the resin will seep and create a dark mark. Let the glue seal coat dry completely before proceeding.

2. **Prepare the project surface.** The polymer coating will drip off the sides of the project, so to prevent drips forming on the bottom, protect the underside by covering the bottom edges with clear cellophane tape. Apply tape to the underside edge of the item and press the tape firmly. If there's any hardware you don't want covered with the coating, remove it.

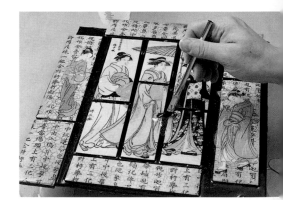

Photo 3

3. **Prepare your work area.** Your work surface should be clean, level, and protected well with wax paper or freezer paper. The item you are covering should be lifted off the work surface about 2" to allow the resin to drip freely off the sides. (Photo 1) (I use small disposable plastic cups for this. For smaller pieces, such as jewelry, use wooden toothpicks stuck into pieces of plastic foam to elevate them.) If you're working in a cold area, first warm the resin and hardener by placing the bottles in a bowl of warm (not hot) tap water.

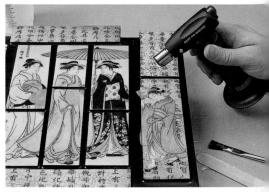

Photo 4

4. **Measure.** When the glue seal coats have dried completely clear, you are ready to mix the two parts of the polymer coating. Place the mixing container on a level surface and put one part resin and one part hardener (exact amounts by volume) into the container. Measure exact amounts – do not guess – or your coating will be soft and sticky and won't harden properly. Mix a minimum of two ounces, but mix only as much as you can use at one time – leftover coating cannot be saved. On average, four ounces of mixed coating covers one square foot.

5. **Mix** the resin and hardener vigorously with a wooden stir stick until thoroughly blended – a full two minutes. The importance of thorough mixing cannot be overemphasized, as poor mixing can result in a soft finish that won't harden. Scraping the sides and bottom of the container continually while mixing is a must. Do not be concerned if bubbles get whipped into the mixture. They are a sign that you are mixing well, and they can be removed after the resin is poured.

6. **Pour** right away, do not wait. Pour the coating over the surface of your item in a circular pattern, starting close to the edge and working towards the center. (Photo 2) This allows the coating to level out. Help spread where necessary with a disposable glue brush, but don't spread the coating too thin or the surface will be wavy. You have approximately 25 minutes to work before the coating starts to set up. For a paper mosaic effect, use the brush to remove excess coating from the "grout" lines (the spaces between the paper pieces. (Photo 3)

7. **De-gas.** Within 10 minutes of pouring, air bubbles created while mixing will rise to the surface and begin to break. Gently exhale (but don't blow) across the surface – the carbon dioxide in your breath will break the bubbles. On large surfaces, use a small propane torch to remove air bubbles. Hold the torch at least three to four inches from the surface. (Photo 4) **The resin contains no flammable solvents, and gasses from a propane flame are rich in carbon dioxide. (It is the carbon dioxide – not the heat of the torch – that removes the bubbles.)**

8. **Remove drips.** Wait 30 minutes, then wipe away any drips from the bottom of the project with a glue brush. Wait 30 minutes and repeat. After the coating has cured, remove any tape from the bottom edge of your project and the drips will pop off. TIP: If you didn't use tape, sand off any unwanted drips of cured coating. A circular sanding attachment on a hand drill works well.

9. **Allow to cure.** Allow the coated item to cure in a warm, dust-free room that is closed to pets and children for a full 72 hours to a hard and permanent finish before using or displaying. Discard the mixing cup, the stir stick, and the brush.

Caring for a Resin Finish

Apply a thin coat of furniture polish or carnauba based car wax using a rag. When dry, buff the piece briskly with a soft rag. This will prolong the life of the polymer coated surface and help decrease smudges and fingerprints.

Heavy items placed on the surface for long periods of time may leave a slight impression on the coated surface. Once the object is removed, the impressions will disappear in a few hours.

When I give handmade gifts that have been coated, I send along a care card. Here is a sample of a care card for a set of coasters:

> *These coasters are heat resistant, waterproof, and alcohol proof.*
> *Clean with a soft damp cloth.*
> *Carnauba car polish will prolong the life of the surface and remove smudges and fingerprints.*
> *Objects, when left on the surface for a period of time, may leave impressions but will disappear in a few hours at normal room temperature.*

Example of care card.

Gift of a Garden
GREETING CARDS

The art of collage works well for card making. Because a card is a small surface, it doesn't take a lot of materials or time to create a striking work of art. The theme for this card design is the vintage garden. Any old, distressed-looking decorative papers can be used if you cannot find weathered wood, rusted metal, or stone design paper. You could also make your own rusted garden shapes, using the rusted metal paint method on a simple motif cut from card stock. The plant marker is a fun addition that can be used as a bookmark or to decorate an indoor plant.

SUPPLIES

Base:
Decorative paper with weathered wood look, 10½" x 6"

Papers:
Pages from an old garden book (best with black-and-white images)

Paper images *or* stickers – Garden sayings, floral postal stamps, seed packages

Decorative paper – Rusted metal and stone designs

Embellishments:
Charms – Rusted garden motifs, silver garden charm

Copper eyelets

Black wire

Amber chip beads

Wooden plant marker

Tools & Other Supplies:
Kraft envelope, 5¼" x 7"

Cutting mat, ruler, and art knife

Glue stick Scissors

Craft glue Walnut ink

Colored chalk

Brown acrylic antiquing gel

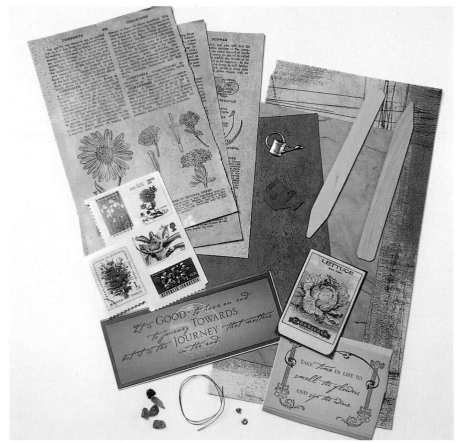

Collage Supplies

INSTRUCTIONS

1. Using the card shape pattern provided and the cutting mat, ruler, and art knife, cut the card base from the weathered wood decorative paper. Fold to make the card.

2. Choose some pages from the garden book that you wish to use on the front of your card and to line the inside of the card. Antique the pages by spraying them with a light solution of walnut ink. Let dry.

3. Color some of the images on the garden book pages with colored chalk.

4. Cut a piece of the garden book page to fit the inside of the card and glue it in place using a glue stick.

5. Using the glue stick, create a collage on the front of the card. You can use a garden quote as the focal point. Layer a torn piece of a garden book page, a garden quote, and floral postage stamps.

6. Glue a rusted garden motif to the collage with craft glue.

7. Attach two copper eyelets, thread black wire through the eyelets, and wrap the garden charm on one end of the wire, curling the wire end to secure the charm. Thread amber chip beads on the other end of the wire.

8. Finish the inside of the card with a 3" square panel cut from stone decorative paper. This will be the area where you will write your sentiment.

9. Stain the wooden plant marker with acrylic gel.

10. Glue the seed package motif at the top of the plant marker and place it inside the card. ❑

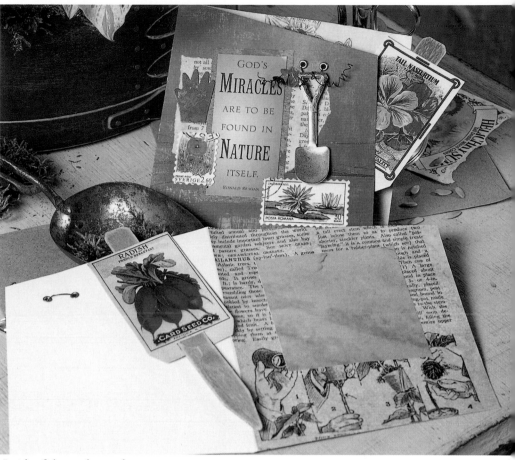

Inside of the garden card.

Pattern for card shape
Enlarge @200% for actual size.

Playing the Game

GREETING CARDS

These cards use playing cards and game pieces to convey a message. You could, for example, glue a playing card on the inside with the same number as the age or anniversary of the recipient. Or make a Valentine's Day card with the queen or king of hearts.

SUPPLIES

Base:

Card stock, black, 5½" x 8½" (per card)

Papers:

Black and white polka dot paper, 3" x 4" (1 per card)

Round stickers with words, 1½", ¾" (1 of each per card)

Miniature playing cards, 1" x 1½" (5 per card)

Domino image *or* sticker (1 per card)

Embellishments:

Domino, 1¼" x 5/8" (1 per card)

6" black and white ribbon, 5/8" wide (1 piece per card)

8" black satin ribbon, ⅛" wide (1 piece per card)

Mini black clip (1 per card)

Tools & Other Supplies:

Scissors

Cutting mat, ruler, and art knife

Bone folder

Glue stick

White craft glue

Clear dimensional varnish

Dimensional glue dots

White gel pen

Black envelope, 6½" x 4¾"

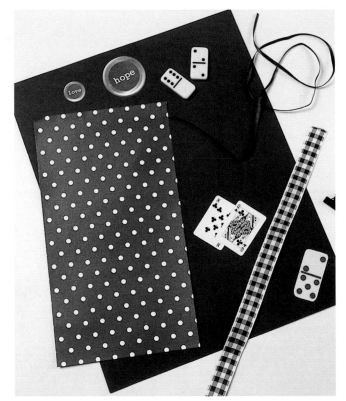

Collage Supplies

INSTRUCTIONS

1. Fold the black card stock in half to create a 4¼" x 5½" card.
2. Use the bone folder to score a line on the front of the card ½" from the fold. Fold on the scored line. (This prevents the black clip from hindering the opening of the card.)
3. With a white gel pen, write "Ace," "King," or "Queen" (or a number to match the card you're using) around edge of the card to create the border.
4. Glue the polka dot panel to the front with a glue stick.
5. Cut four playing cards into quarters from corner to corner, using the ruler and art knife.

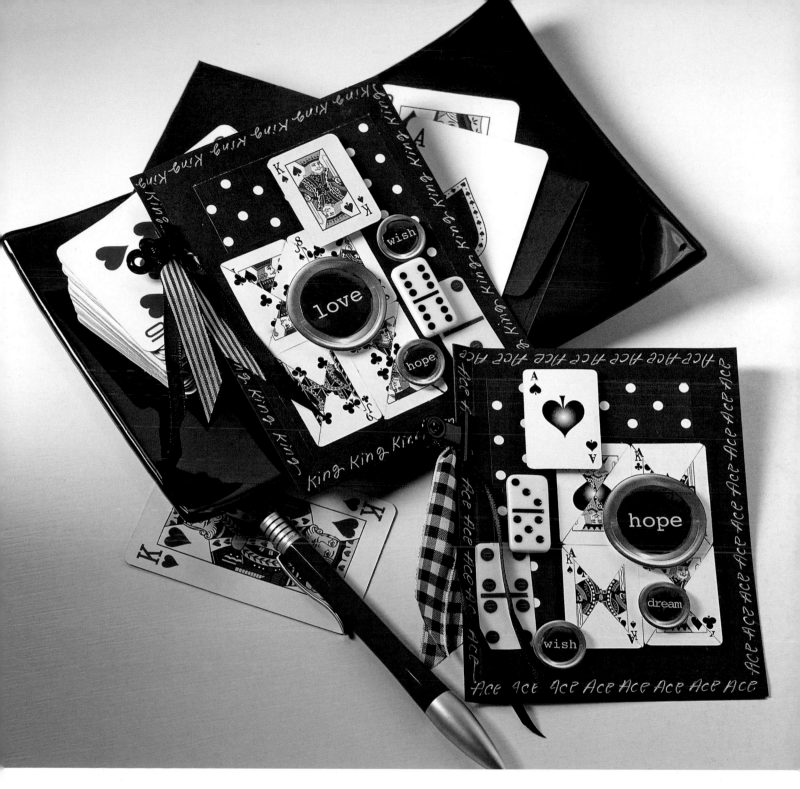

6. Mix up the card pieces to create the design and glue in place, overlapping the polka dot panel.

7. Attach the round word stickers with dimensional glue dots, making the larger one the focal point.

8. Attach the remaining playing card with dimensional glue dots.

9. Glue the paper domino image in place with the glue stick.

10. Use craft glue to glue the domino in place.

11. Apply dimensional varnish to the round motifs. Let dry completely.

12. Attach the ribbons to the fold with the black clip. ❑

A Fitting Greeting
PUZZLE CARDS

Puzzle pieces make interesting dimensional elements for collages. You can use blank puzzle pieces (find them at crafts stores) or recycle pieces from a discarded puzzle. Collage puzzle pieces could also be used to decorate scrapbook pages, altered books, or make gift tags.

Tags are pictured on page 40.

SUPPLIES

For one card

Base:

Card stock, light teal, 8½" x 4"

Papers:

Puzzle piece, 3" x 2½"

Vintage image

Gold metallic paper

Gold sticker dots

Rust decorative paper, 3¾" square

Embellishments:

Tiny metal tags – Copper, gold

Brads – Green, copper

Paper flower, ¾" – Soft peach, taupe, *or* tan

Peel-off sticker with greeting (e.g., "Best Wishes," "Happy Birthday")

Decorative fibers to match, 3 lengths, each 14" long

Tools & Other Supplies:

Dimensional glue dots

Decorative fibers, two 12" lengths

Gesso

Acrylic craft paint – Dark moss green

Metallic wax – Copper

Glue stick

Decoupage medium, satin sheen

Awl

Inkpad – Vintage sepia

Stencil brush

Pencil, art knife, and cutting mat

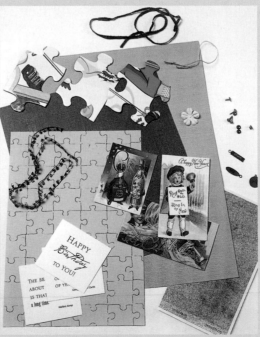

Supply photo also pictures supplies used for the tags on page 40.

INSTRUCTIONS

Prepare the Puzzle Piece:

1. Brush a coat of gesso on the puzzle piece. Let dry.
2. Paint the puzzle piece with dark moss green paint. Let dry.
3. Crop the vintage image to approximately 2" x 3". Glue to a piece of gold paper, using a glue stick.
4. Trim the gold paper to create a ⅛" wide border around the image.
5. Place the image on the puzzle piece. Turn over and mark where to trim. Trim the image to fit the puzzle piece.
6. Using decoupage medium, glue the image on the top of the puzzle piece. Let dry. Apply with another coat of decoupage medium. Let dry.
7. Accent the edges of the puzzle piece with copper metallic wax.
8. Using an awl, make holes in the puzzle piece to attach the tiny metal tags and paper flower with brads.
9. Attach the tags and the flower.

Make the Card:

1. Fold the light teal card stock to make a card with 4" front and a 4"½ back.
2. Place the peel-off greeting sticker on the ½" extra margin on card back.

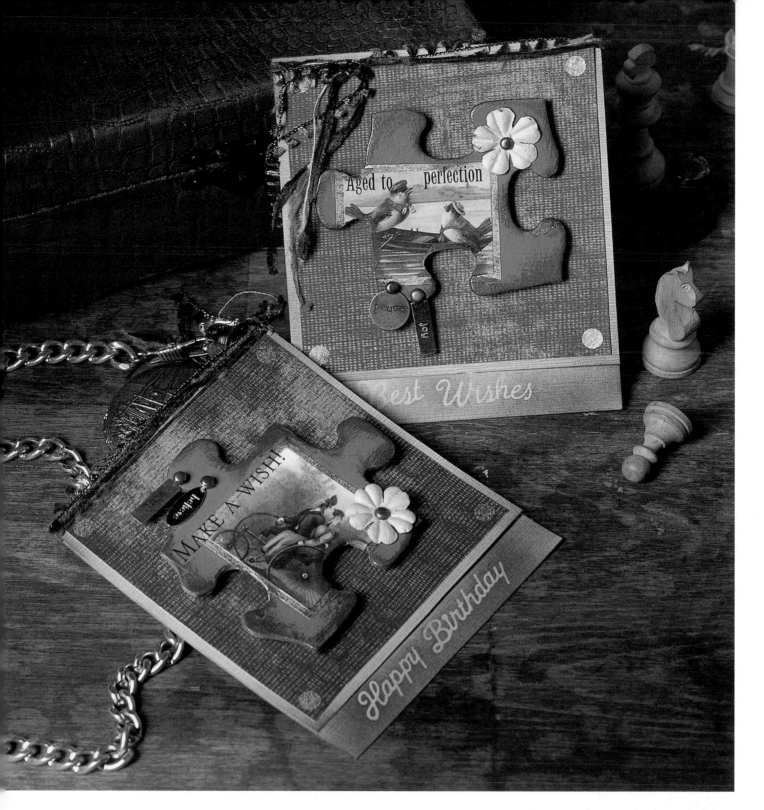

3. Antique the edges of the card and the entire flap, antiquing over the sticker. Use the sepia ink from the inkpad and a stencil brush. Remove the peel-off sticker to reveal the lettering.

4. Glue the rust paper panel to the front of the teal card.

5. Add gold sticker dots in the corners of the rust piece.

6. Mount the puzzle piece to the front of the card with dimensional glue dots.

7. Wrap the decorative threads around the fold of the card and knot to secure. ❑

A Fitting Gift

PUZZLE TAGS

SUPPLIES

For one tag

Base:

Card stock, puzzle print

Papers:

Puzzle piece, 3" x 2½"

Vintage image

Gold metallic paper

Embellishments:

Tiny metal tags – copper, gold

Brads – Green, copper

Paper flower, ¾" – Soft peach, taupe, *or* tan

Decorative fibers to match, three 14" lengths

Tools & Other Supplies:

Gesso

Acrylic craft paint – Dark moss green

Metallic wax – Copper

Glue stick

Decoupage medium, satin sheen

Awl

⅛" hole punch

Inkpad – Vintage sepia

Stencil brush

Art knife, pencil, and cutting mat

INSTRUCTIONS

Prepare the Puzzle Piece:

Follow the instructions for the Puzzle Piece Card.

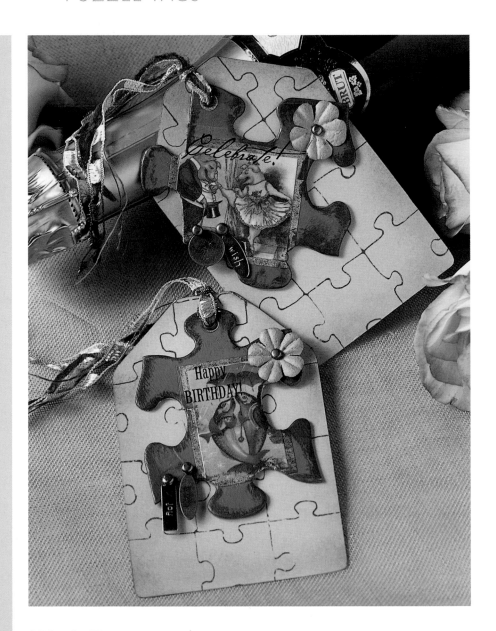

Make the Tag:

1. Cut a tag 3" x 4½" from the puzzle print decorative paper.
2. Antique the edges with the sepia ink from the inkpad and a stencil brush.
3. Make holes at the top of the puzzle piece and the tag with the hole punch.
4. Glue the puzzle piece to the tag, matching the holes.
5. Thread the decorative fibers through the holes. ❏

Pretty as a Picture

ACCORDION PHOTO CARD

Instructions begin on page 42.

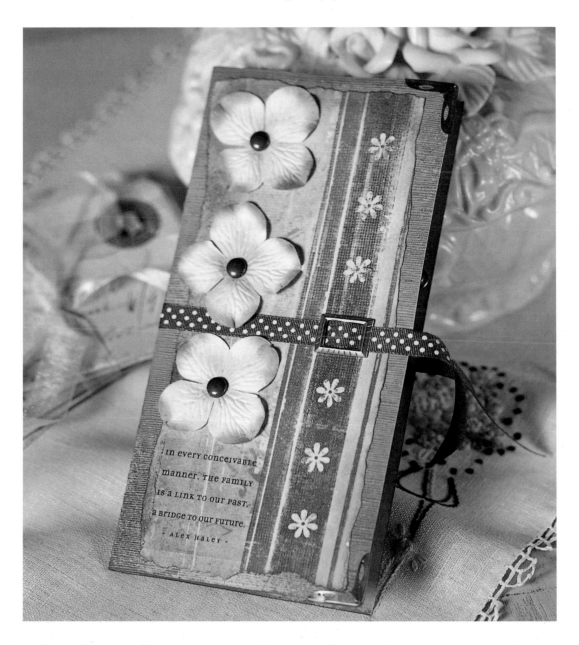

This photo album card has an accordion-folded inside panel that opens to reveal the vintage photographs. (A photo appears on page 43.) It's a nice design for an anniversary card or birthday card because it showcases both old and new photographs. Consider color photocopying new color photographs in sepia tones to match the look of the vintage photos.

Pretty as a Picture
ACCORDION PHOTO CARD

Front of card pictured on page 41.

SUPPLIES

Base:

Card stock, dusty pink 8" square, 8½" x 11"

Papers:

Photocopies of photographs (5 in all)

Clear quotation stickers

Decorative paper, pink and brown, in three different designs (One design should be light colored)

Embellishments:

6 copper brads

2 gold photo turns

3 pink flowers

2 pieces brown and ivory polka dot ribbon, one 14", one 5"

1 gold ribbon buckle

1 round copper charm, ¾"

2 copper metal corners

Tools & Other Supplies:

Inkpad – Vintage sepia

Stencil brush

Glue stick

Paper trimmer

Double-sided tape

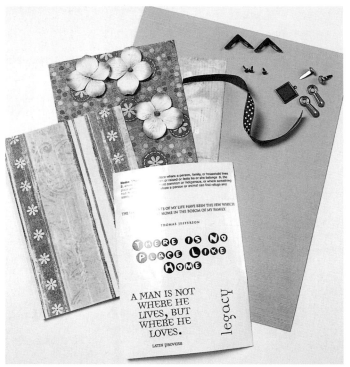

Collage Supplies

INSTRUCTIONS

1. Fold the 8" square card piece in half to create a 4" x 8" card base.
2. Cut two strips, each 4" x 11", from the 8½" x 11" card piece.
3. Use double-sided tape to attach the pieces, overlapping them ½" to form a strip 21½" x 4".

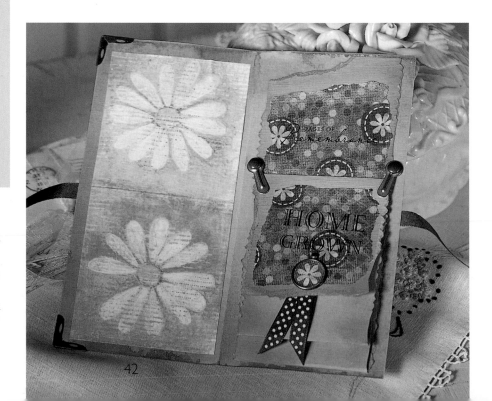

4. Accordion fold this strip to form five panels (in order) 8", 3", 2½", 4", and 4".

5. Tear all the edges of the accordion panel.

6. With the sepia inkpad and stencil brush, antique the edges of the folded card, inside and out, and the torn edges of the accordion-folded panel.

7. Tear the decorative paper into pieces to fit each of the accordion-folded panels and the front of the card. Antique all the edges of all the pieces with sepia ink.

8. Mount the torn panels in place on the card and folded panel, using the glue stick.

9. Trim the photos and mount on the accordion-folded panel.

10. Using double-sided tape, mount the accordion panel inside the card.

11. Place the clear quotation sticker on the front panel.

12. Use brads to attach the paper flowers to the front panel.

13. Attach the metal corners, crimping them to hold.

14. Use double-sided tape to attach the ribbon and ribbon buckle.

15. Cut a 3½" x 7½" panel from one of the decorative papers. Glue to the inside left panel of the card. (This hides the backs of the brads and give you a place to write a personal message.)

16. Fold up the accordion panel. Secure with brads and the photo turns.

17. Accent the metal charm with a piece of the decorative paper cut to fit. Attach the charm and a 5" piece of ribbon to the bottom of the accordion panel with the remaining brad. ❑

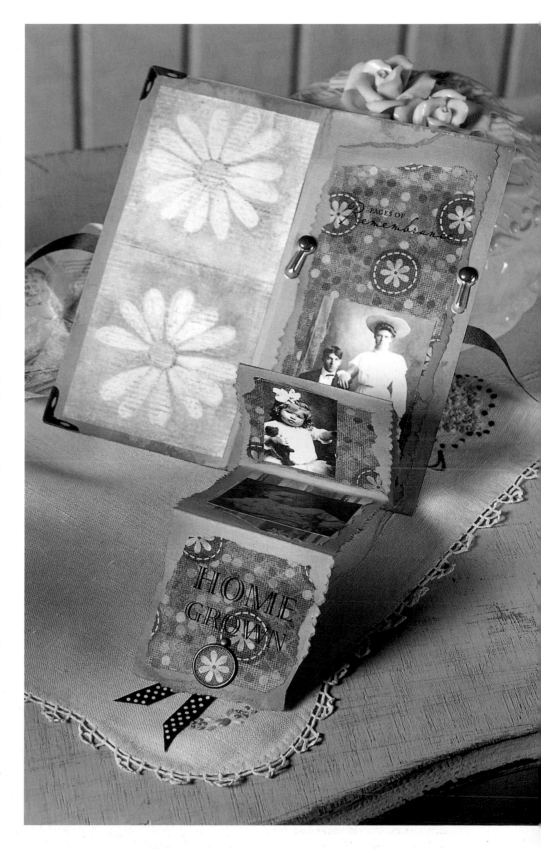

Friends Puzzle
FRAMED COLLAGE

A puzzle with large pieces is used as a base for this framed collage with a modern art look. A book of fine art stickers (these are Picasso's) makes this piece easy to do. You could personalize the puzzle by including photos of your friends and by generating the title, names, and sayings on your computer and photocopying them on decal transfer film. (See the "General Information" chapter for instructions.)

SUPPLIES

Base:
Puzzle with large pieces, 13" x 10"

Papers:
Picasso stickers
Heart stickers
Transparency – Friendship sayings, line drawing stickers
Title sticker (e.g., "Friends 4 ever")

Embellishments:
Rhinestone stickers – Pink, purple, clear
4 puzzle pieces, each about 1"

Tools & Other Supplies:
Gesso
Acrylic paint – Antique white
Acrylic antiquing gel – Dark brown
Bone folder
Scissors
Matte varnish
Clear dimensional varnish
Dimensional glue dots
Inkpad – Vintage sepia
Stencil brush
Sticky notes (for masking)
Black wooden frame (to fit puzzle)
Paper towels

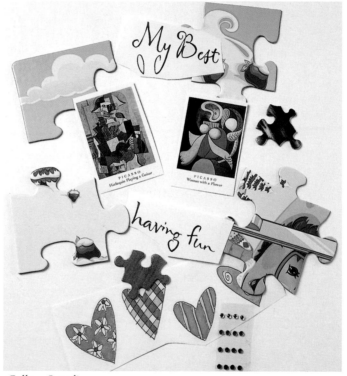

Collage Supplies

INSTRUCTIONS

1. Assemble the large puzzle and the four small puzzle pieces together and paint with gesso. (The coating of gesso will keep the puzzle pieces together.) Let dry.
2. Paint the assembled puzzle pieces with antique white. Let dry completely.
3. Working one small (4" square) area at a time, antique the puzzle pieces: brush on antiquing gel and immediately wipe off with a paper towel. (This emphasizes the lines between the pieces.) Let dry. Set aside the assembled small puzzle pieces.
4. Without removing the stickers from the backing paper, arrange the motifs on the puzzle base. Trim some stickers to fit the puzzle pieces. TIP: To

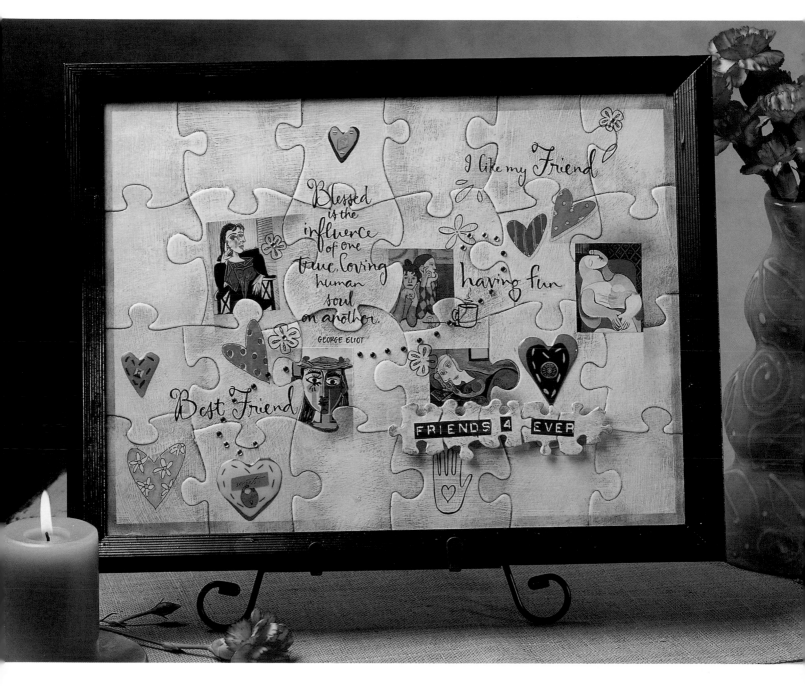

mark for trimming, place the backed sticker over the puzzle piece and rub with a bone folder to mark the edge. Trim as marked, remove the backing paper, and place the sticker.

5. Add the heart stickers, friendship quotes, and black line drawing stickers.

6. Using the sticky notes as a mask, create a "frame" around each Picasso sticker with sepia ink, using a stencil brush.

7. Use the same sticky note technique to create a bor-

der on the outer edge of the puzzle.

8. Mount the prepared small puzzle pieces on the collage with glue dots. Add the title sticker.

9. Coat the entire collage with matte varnish. Let dry.

10. Add clear dimensional varnish to selected heart stickers.

11. Make a swirl with rhinestone stickers. Add rhinestone stickers to the centers of a few flower motifs.

12. Install the collage in the black frame. ❏

Home Sweet Home
FRAMED MIRROR

This collage frame is a great example of how to use themed scrapbook papers and matching stickers to decorate an object. The idea can be used with a variety of themes and color combinations. The supplies are readily available at scrapbooking and crafts stores.

SUPPLIES

Base:

Dark brown wooden frame, 10" square with a 4" square opening

Mirror to fit opening, 4½" square

Papers:

Images *or* stickers – Cross-stitched samplers, tags

Transparency – Family quotation stickers on clear film

3 decorative paper designs in ochre, tans, black, and ivory

Rub-on transfer (to match theme)

Black card stock

Embellishments:

Tags (to match papers)

3-D stickers (to match papers)

1/3 yd. black and white ribbon, cut into three 4" pieces

Resin word stickers

Metal frame charm with photo

Found embellishments – Metal key, buttons

Tools & Other Supplies:

Paper trimmer

Decoupage medium

Dimensional glue dots

Craft glue

Dimensional varnishes – Clear, clear crackle

Matte varnish

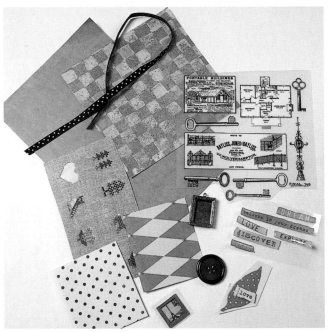

Collage Supplies

INSTRUCTIONS

1. Cut the papers into pieces (3" squares, 3½" x 3", ¾" x 3") using the paper trimmer. See the photo for guidance.
2. Using decoupage medium, glue the paper panels to the frame, starting at the top right corner and going clockwise. Use the photo as a guide.
3. Coat all the pieces with decoupage medium. Let dry completely.
4. Add the clear quotation stickers.
5. Place the cross-stitch and tag stickers on black card stock and trim the black paper to form a ⅛" border.
6. Attach the ribbon pieces to the tags.
7. Use decoupage medium to adhere the cross-stitch sticker pieces.

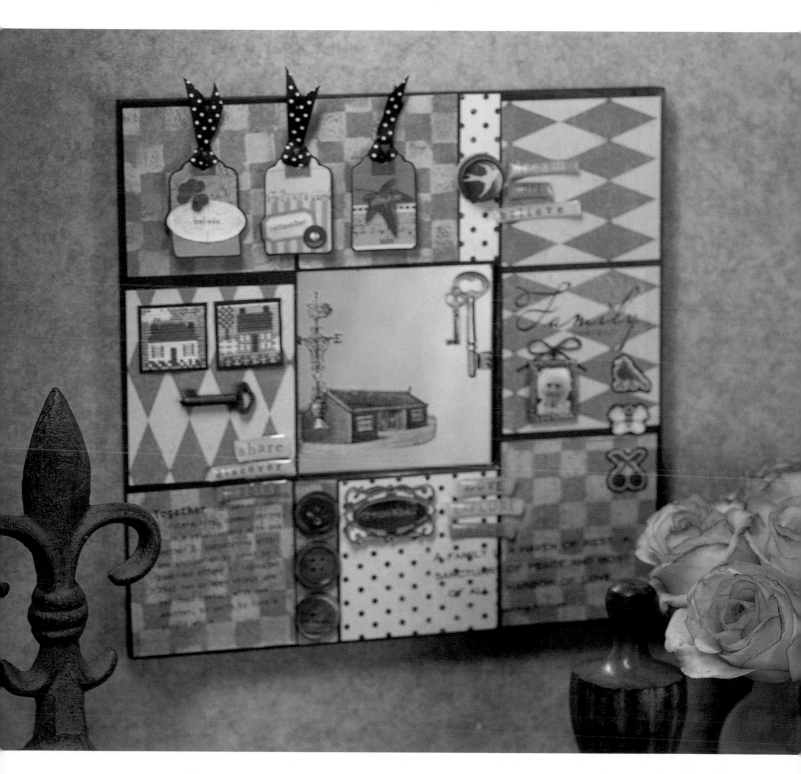

8. Apply a coat of matte varnish to the entire frame.

9. Attach the remaining embellishments. Use white craft glue for the frame, buttons, key, and resin word stickers. Use dimensional glue dots for the tags.

10. Apply dimensional crackle and dimensional clear varnish to the tags and photo. Let dry completely.

11. Decorate the mirror with the home theme rub-on.

12. Install the mirror in the frame and secure with craft glue. Let dry. ❏

Home Sweet Home
PAPERWEIGHT

This paperweight was created to coordinate with the Home Sweet Home Framed Mirror. The clear cast dome magnifies and showcases a collage or photo. You can make up to five different photographs or collages and stack them under the dome to create a changeable display.

See Chapter 11, "Casting Collage," for more about casting.

SUPPLIES

Base:

Round cork coaster, 4" diameter

Tan paper, 3" circle

Papers:

Photographs cropped to 3" circles

Images *or* stickers – Cross-stitched samplers, quotations

Black card stock

Embellishments:

Resin word stickers

Black plastic letters

Tools & Other Supplies:

Epoxy casting resin

Basic casting supplies (See Chapter 11, "Casting Collage.")

Resin dome mold, 3" diameter

Scissors

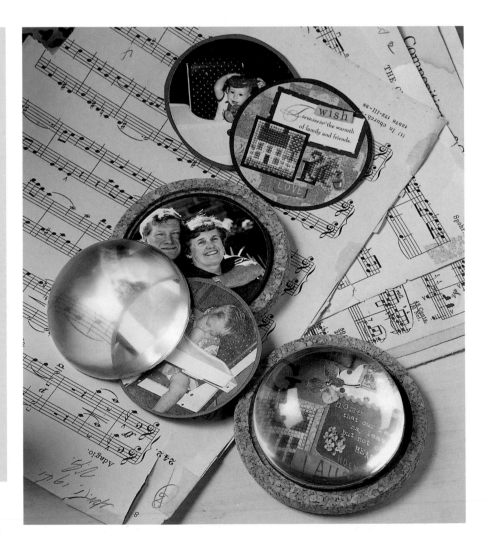

INSTRUCTIONS

1. Following the instructions that come with the casting resin, make a clear dome.
2. Mount the photos on black card stock and cut out, leaving a ⅛" border.
3. Create a collage on the tan decorative paper circle with stickers and embellishments.
4. Mount the collage circle on black card stock. Cut out, leaving ⅛" border.

To use: Stack the photographs and collage circle on the cork coaster with the image you wish to display on top. Place the clear dome on the stack. To change the image, simply reorganize the stack. ❏

File in Style

MAIL & LETTER FILE

Instructions begin on page 50

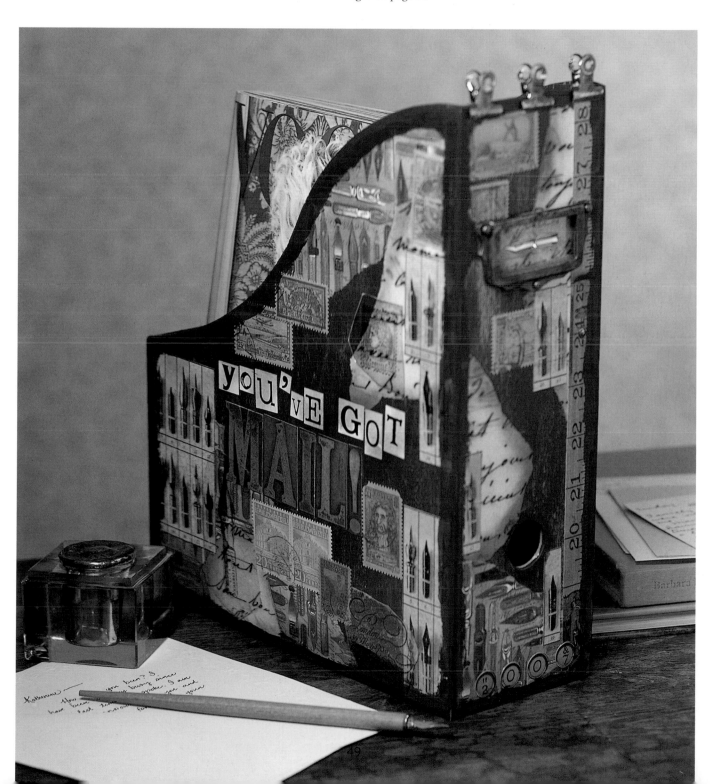

File in Style

Even the bills won't seem so daunting when they're contained in this colorful file box. The layered collage features transparent mica tiles that add sparkle and interest. Other collage items include postcard transparencies, decorative papers, alphabet stickers, and rubber stamping.

SUPPLIES

Base:

Wooden magazine file, 9¾" x 12"

Papers:

Postage stamps

French postcard transparencies

Alphabet stickers *or* paper images

3 decorative papers with vintage block letters, script lettering, pen nib

2 sheets letters decorative paper, 12" square (to line the inside)

Embellishments:

Mica tiles

Rubber stamps – Pen nib, script lettering, postage stamp

Brass label holder

3 small paper clamps

Pen nib

Tools & Other Supplies:

Acrylic paints – Steel blue, maroon

White wax, such as a candle stub

Sandpaper, 300 grit

Petroleum jelly

Inkpads – Sepia, black permanent

Stencil brush

Decoupage medium

Scissors

Craft glue

Collage Supplies

INSTRUCTIONS

Prepare the Base:

See the "General Information" chapter for how to create the "Old Painted Wood" look.

1. Rub the magazine file in random areas with wax.
2. Paint the file with a coat of steel blue paint. Let dry.
3. Add more wax.
4. Apply a coat of maroon paint. Let dry.
5. Sand the box. Where the wax was applied, the paint will sand off easily, leaving areas of wood and steel blue paint visible.

Create the Collage:

1. Tear the script and pen nib decorative papers into large pieces.
2. Use a stencil brush to antique the edges of the paper pieces with sepia ink.
3. Using decoupage medium, glue the pieces to the file.
4. Use decoupage medium to adhere smaller paper motifs (e.g., pen nib images) and the postage stamps.
5. Add vintage block letters or letter stickers to spell a title for your collage on the sides. (I added "Love Letters" and "You've Got Mail!" to mine.) TIP: If the letter stickers are white, antique them with sepia ink before attaching them.
6. Add the French postcard transparency with decoupage medium.
7. To line the file, glue the letters decorative paper to the inside. Let dry. Sand the edges to remove the excess paper. (See the "General Information" chapter.)

Finish:

1. Apply two coats of matte varnish to all the sides and the inside of the file. Let dry between coats. Let the second coat dry completely.
2. To create the painted borders, apply 1" wide bands of petroleum jelly ½" from the edges of the collage panels.

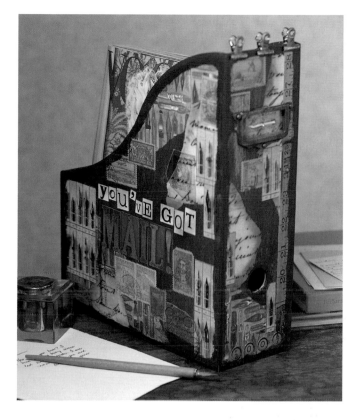

3. Paint the edges of the collages with maroon acrylic paint; don't go over the petroleum jelly. Let the paint dry. Rub off the petroleum jelly with a soft cloth, leaving a painted border around all the edges.
4. Stamp the mica tiles using the black permanent inkpad. Let dry.
5. Attach the mica tiles to the collage with the decoupage medium.
6. Use white glue to attach the pen nib and label holder to the front of the file.
7. Paint the paper clips, following the instructions for "Enhancing Metal Embellishments" in the "General Information" chapter. Let dry. Clip them to the top of the file to hold outgoing letters. ❑

About Mica Tiles

Pieces of mica, a natural mineral that can be separated into four to eight thin layers, are a wonderful addition to collages. Mica has a clear topaz brown coloring (thicker sheets are deeper in color) and a natural shimmer. The transparent sheets can be cut with scissors, layered, and stamped with permanent inks. Use them over paper images, gluing them in place with decoupage medium.

Nature Tiles

COASTERS

These simple collages are made using only three different elements: pressed oak leaves, printed images (be sure they're copyright-free), and quotations on clear stickers or transfer film. If you wish to generate your own quotations, print them on your computer, then photocopy in black onto decal transfer film. The polymer coating provides a waterproof, practical surface.

SUPPLIES

Base:

4 tumbled marble tiles, 4" square

Collage Elements:

Quotations on clear stickers *or* decal transfer film

Images of oak leaves and acorns

Pressed oak leaves

Tools & Other Supplies:

Acrylic paint – Moss green

Scissors

Basic supplies for polymer coating (See the "General Information" chapter.)

Thin-bodied white glue

Paper towels

Collage Supplies

INSTRUCTIONS

1. Paint the edges of the marble tiles with moss green, wiping the tops of tiles with a paper towel smooth and blend the edge of the paint.
2. Create transparencies by color photocopying the copyright-free leaf images in sepia tones on decal transfer film. Trim the images to 4" square.
3. Slide the transfers onto the tiles, following the instructions in the "General Information" chapter. Let dry completely.
4. Add the quotation stickers to the tile.
5. Using white glue attach the pressed leaves to the tiles.
6. Coat the entire tile with two thin coats of thin-bodied white glue to seal. Let dry completely. **Note:** You must seal the decal transfer film with glue before applying the polymer coating. If you don't, the coating will bead up on the film.
7. Apply the polymer coating to the coasters, following the instructions in the "General Information" chapter. ❏

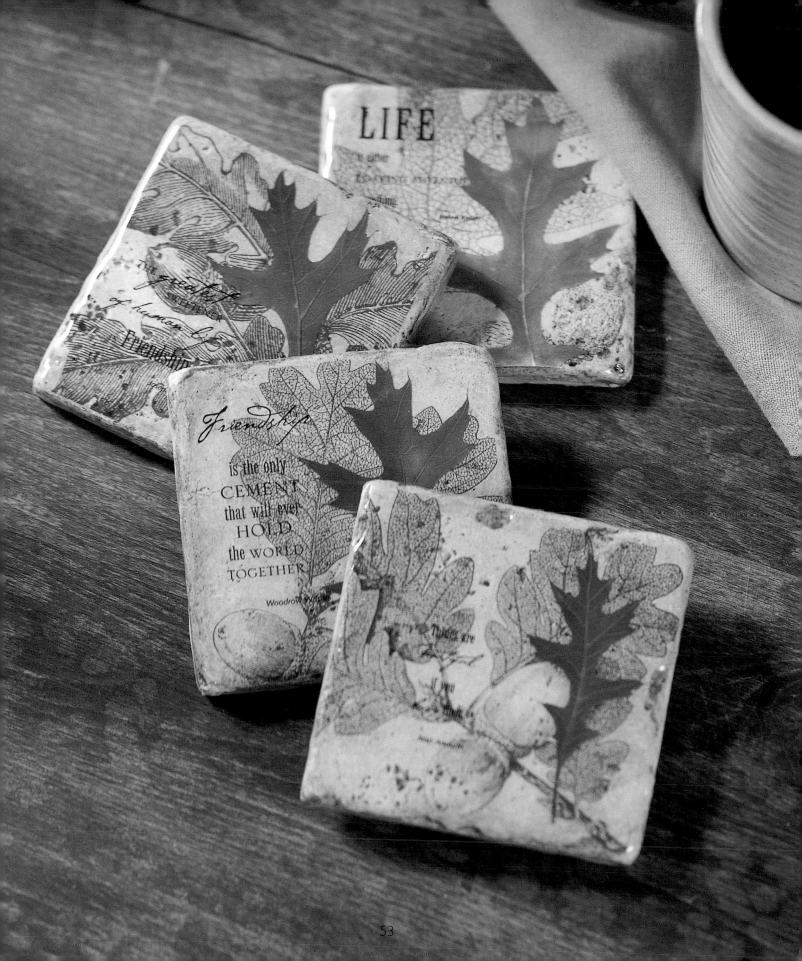

Organized Sewing
TIN SEWING BOX

A metal box was chosen as the base for this project so strong magnets could be used to hold scissors, pins, needles, and other tools to the top of the box. The collage design changes as you remove the tools to use them and move the magnets. Use the box to store spools of thread, sewing machine attachments, buttons, and notions.

SUPPLIES

Base:

Metal box with lid, 8" x 6-1/4" x 3"

Papers:

Pattern tissue

Paper images *or* stickers - Vintage sewing images, wooden ruler

Black-and-cream checked decorative paper

Embellishments:

Twill ribbon printed with measuring tape motif

Ribbon buckle

30 " black rick rack, 1/4" wide

Assorted buttons

Tools & Other Supplies:

Decoupage medium

Strong magnets

Sandpaper, 300 grit

Double-sided tape

Matte varnish

Craft glue

INSTRUCTIONS

1. Tear the pattern tissue into 3" x 4" pieces.
2. Use decoupage medium to adhere the pieces to the sides of the box base and the top of the lid. Don't glue any tissue around the top edge of the base where the lid overlaps the base.
3. Decoupage the vintage sewing images on the top of the lid.
4. Use decoupage medium to adhere the wooden ruler image around the edge of the lid.
5. Place the checked paper face down on your work surface and glue the magnets to it, using decoupage medium. Let dry. Trim the paper and sand flush with the edges of the magnets.

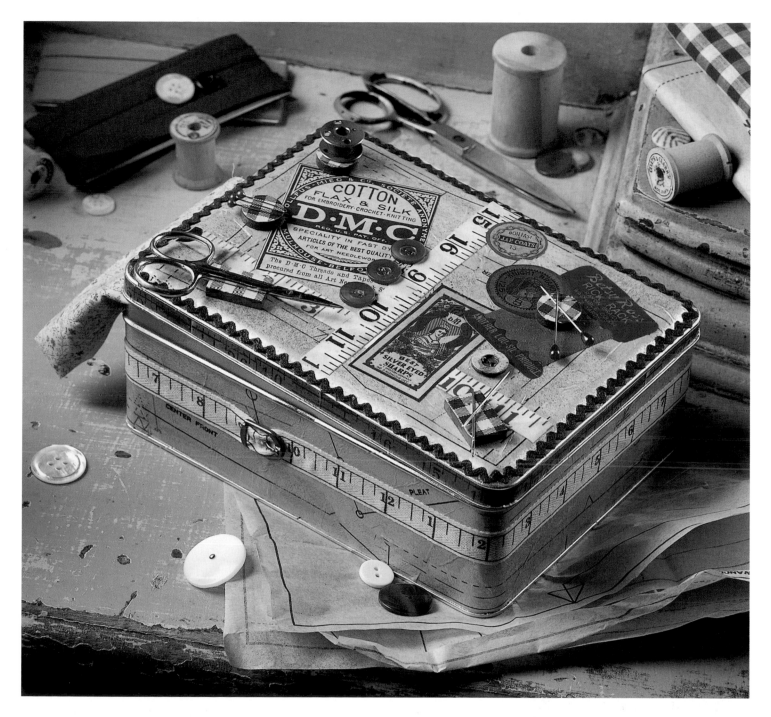

6. Thread the ribbon buckle on the measuring tape ribbon. Attach to the box with double-sided tape.

7. Glue the black rick rack around the top edge of the lid, using the craft glue. Let dry.

8. Coat the top of the lid including the rick rack, the box sides including the ribbon, and the tops of the magnets with two coats of matte varnish. Let dry.

9. Glue the buttons to the top of the box with craft glue.

10. Arrange the magnets on the top of the box. Use them to hold metal tools (scissors, pins, needles, etc.) in place. ❑

Bold Botanical
SERVING TRAY

This bold geometric design uses printed pages from a discarded book that were tinted with tea and coffee and botanical transparencies. A polymer coating protects the collage. Display it on an easel when you're not using it.

SUPPLIES

Base:
Round wooden plate, 13½" diameter

Papers:
Printed pages from a book, cut into 50 rectangles, 2½" x 3½"

Contact Paper Transparencies:
See the "General Information" chapter for instructions.

3 color transparencies (made from botanical print gift wrap)

3 black-and-white transparencies (made from line drawings of flowers from a copyright-free book)

Tools & Other Supplies:
Gesso

Tea bags

Instant coffee

Basic supplies for polymer coating (See the "General Information" chapter.)

Decoupage medium

Thin-bodied white glue

Art knife, cutting mat, and ruler

Sandpaper, 300 grit

Collage Supplies

INSTRUCTIONS

1. Coat the plate with gesso. Let dry.
2. Following the instructions for "Antiquing Paper with Coffee & Tea," tint eight of the rectangles you cut from the book pages with a strong tea solution and eight rectangles with a weak tea solution. Tint 12 rectangles with a coffee solution. Leave the rest of the rectangles untinted.
3. Using the photo as a guide for placement, decoupage the untinted paper pieces to the plate. Overlap them slightly so they completely cover the gesso. Start in the middle of the plate, keeping the pieces straight and even. At the edges, trim away the excess paper, leaving a ¼" overhang.
4. Working on a cutting mat, cut the tinted rectangles into quarters corner to corner, using the art knife and ruler.
5. Decoupage the tinted paper pieces over plate in this order: Dark coffee-tinted pieces at the top, dark tea-tinted pieces on the right, and light tea-tinted pieces

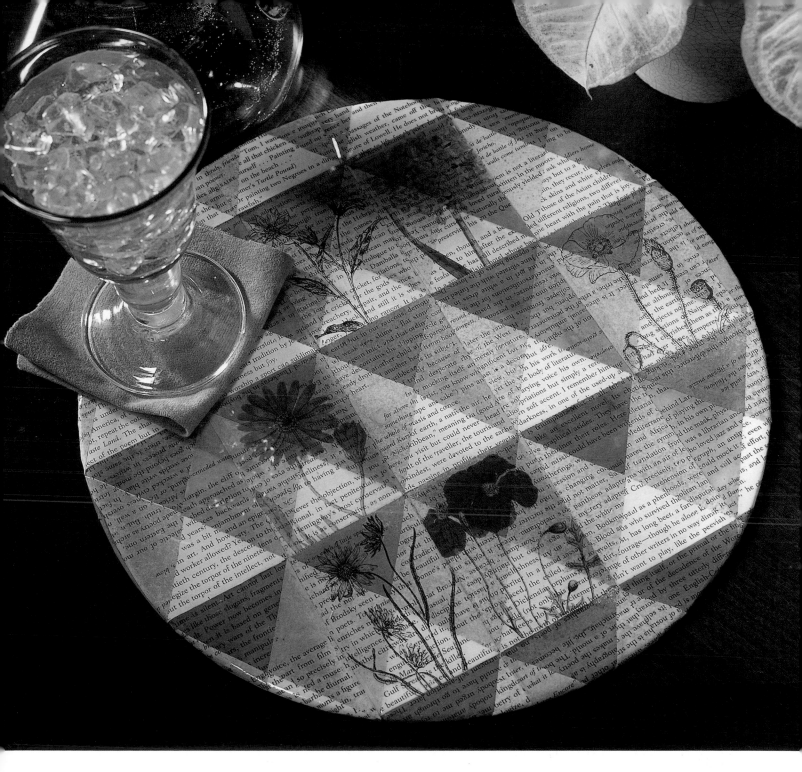

on the left. TIPS: Do not worry if some of the printing is upside down. The intensities and the colors will not be perfect; that's okay – this adds to the vintage look. Let the glue dry completely.

6. Sand the paper that overhangs the edges of the plate.

7. Following the instructions in the "General Information" chapter, make the transparencies.

8. Using the photo as a guide for placement, glue the transparencies in place with decoupage medium. Let dry.

9. Coat the entire tray with two coats of thin-bodied white glue. **Note:** You must seal the transparencies with glue before applying the polymer coating. If you don't, the coating will bead up.

10. Apply a polymer coating to the entire plate, following the instructions in the "General Information" chapter. ❏

Live-Love-Laugh
WOODEN PURSE

The colors of this collage purse are black and white. It's accented with a bright red tassel, which could be easily changed to coordinate with the color of your party dress. Live-Love-Laugh metallic words and dimensional letter stickers spelling "Party Time" provide the theme while mini mirrors and rhinestones add to the glitzy glam.

SUPPLIES

Base:
Wooden box, 5" x 7"

Papers:
Black and white toile decorative paper, 12" square

Black and white checked paper, 12" square

Black and white fabric panel stickers *or* patterned paper

Black and white paper with words

Black and white border stickers

Embellishments:
Metal word stickers – "live," "love," "laugh"

Dimensional letter stickers

Square mirrors – ¼", ½", 1"

Clear rhinestones

Red tassel *or* red decorative fibers, satin ribbon, rick rack, thin red wire to make a tassel

Lanyard

Tools & Other Supplies:
Acrylic paint – Black

Black bamboo purse handle

Silver handle clamps

Scissors

Decoupage medium, matte sheen

Craft glue

Art knife, ruler, and cutting mat

Optional: Silver metallic paint

Papers

Supplies

INSTRUCTIONS

1. Remove the hardware from the box.
2. Basecoat the inside with black acrylic paint.
3. Using decoupage medium, cover the top, front, and back of the box with toile design paper. Cover the sides with checked paper. Sand the edges for a flush finish.
4. Arrange and glue the patterned paper or fabric stickers, border stickers, and words to the box. Use the project photo as a guide for placement.
5. Cover with two coats decoupage medium. Let the first coat dry completely before applying the second. Let the final coat dry completely.
6. Reassemble the box and attach the purse handle.
7. Apply the metal word and the dimensional letter stickers. *Option:* Paint the top edges of the dimensional stickers with metallic silver paint.
8. Apply the tiny mirrors and rhinestones with craft glue.

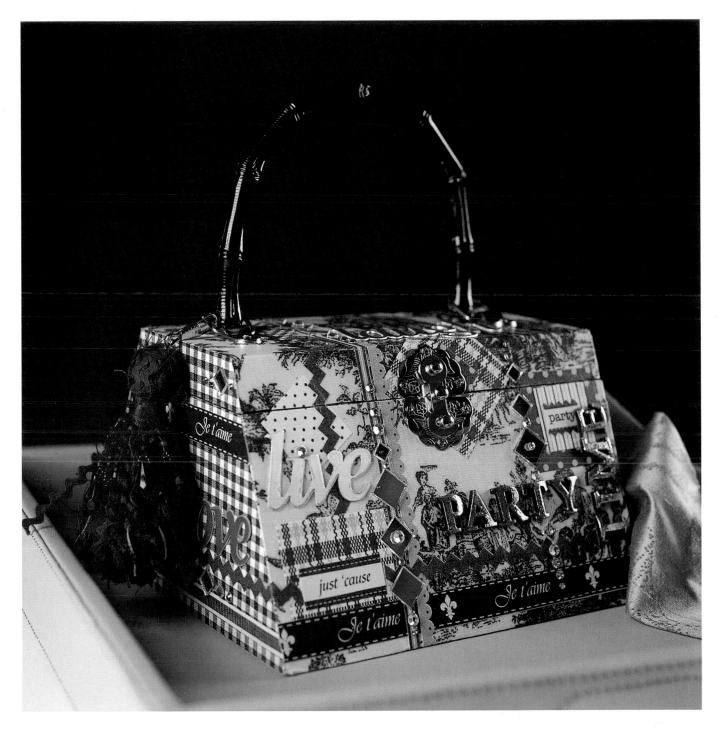

9. Attach the tassel to the handle with the lanyard *or* make a tassel. Here's how: Cut a variety of ribbons, trims, and fibers into 8" lengths. Bundle and wrap the center with a piece of wire. Fold in half to form the tassel. Using another piece of wire, wrap 1" down from the center to form the top. Cover this wire by wrapping and gluing on a length of red satin ribbon. Thread the lanyard through the wire at the top of the tassel. Clip to the purse handle. ❏

Miniature Collage Jewelry

These miniature collage pieces are wonderful conversation starters! The basic techniques are the same — different images, bezels, and bead colors create the various pieces. I like to use small books of vintage images when creating these pieces, but photographs and images from magazines also work well. These miniature masterpieces use a very small amount of polymer coating; it's a good way to use the leftover drops of coating from other projects. You can find bezels of all sizes and shapes in the scrapbook embellishment aisle of crafts stores. If the bezel has a loop for hanging, you can remove it with wire cutters.

The finished pieces can be worn as pendants, topped with a bow and used as holiday tree ornaments, or attached to gift-wrapped packages.

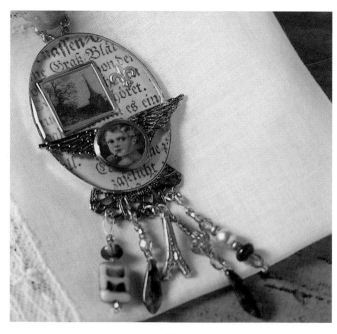

Basic Supplies

Collage Elements:

Bezels

Paper images

Charms, filigree pieces, findings

Beads

Headpins

Jump rings

Tools & Other Supplies:

Scissors

Thin-bodied white glue

Roundnose pliers

Jewelry glue

Basic supplies for polymer coating (See the "General Information" chapter.)

Optional: Craft stick

Jewelry Basic Instructions

Trim the Images:

1. To trim the images to fit the bezels, push the paper image into the bezel and use a craft stick or your fingernail to press the paper right into the edges.

2. Remove the paper and cut along the impressed line of the bezel.

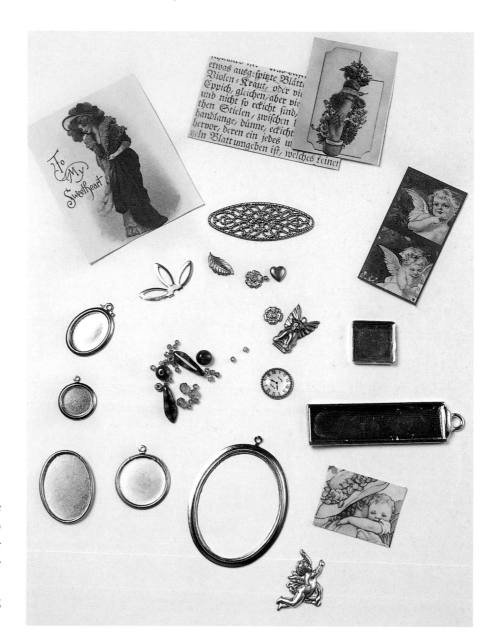

Assemble:

1. Use craft glue to adhere the trimmed images in the large and small bezels. Coat the paper with glue to seal. Let dry.

2. Glue the smaller bezels and small charms on the larger bezel.

3. Glue filigree pieces and jewelry findings on the large bezel with jewelry glue. Let dry completely.

Coat:

Coat the image inside each bezel with polymer coating. See the "General Information" chapter for instructions. Be careful not to let the coating overflow the bezel. TIP: If the coating does overflow, simply let it cure, then sand off the excess.

Embellish:

1. Thread the beads on head pins. Make a loop at the top of each pin with roundnose pliers.

2. Attach the bead dangles and tags to the filigree pieces with jump rings. ❏

For a New Mommy
COPPER PIN

This would make a lovely gift for a new mom or grandmother.
For a boy baby, use blue beads instead of pink ones. To assemble,
follow the Basic Instructions at the beginning of this chapter.

SUPPLIES

Collage Elements:

2 oval gold bezels, one 2" x 1",
 one ½" x 5/8"

Two copper filigree pieces, each
 1¾" x 5/8"

Small paper images – Mother and
 baby, Victorian lady

Beads – Pearls, light pink glass,
 clear crystals

Small cherub charm glued to a tiny
 oval tag

Tiny heart charm

Pin back

Copper jump rings

Gold headpins

Tools & Other Supplies:

See the list of "Basic Supplies" at
 the beginning of this chapter.

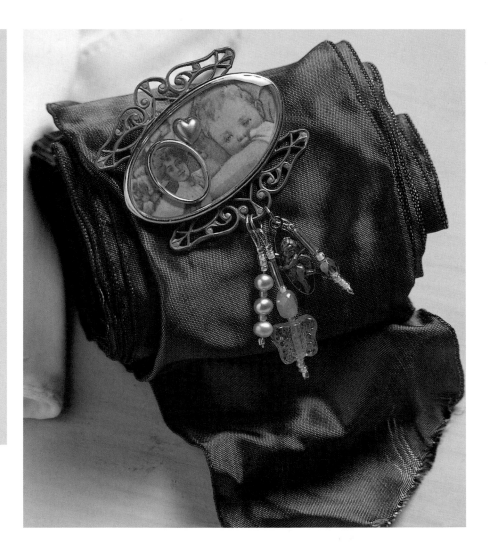

Assemble as instructed under "Jewelry Basic Instructions" at the beginning of
this chapter.

French Angel
PENDANT NECKLACE

An angel image and French symbols (fleur de lis, the Eiffel Tower) are
combined to create this pendant, worn on a length of sheer gold ribbon.
To assemble, follow the Basic Instructions at the beginning of this chapter.

SUPPLIES

Collage Elements:

Oval bezel, 1½" x 2"

Square bezel, ¾"

Round copper bezel, ½"

Gold metal filigree piece

Papers – Calligraphy lettering,
cherub, country landscape

Angel wing charm

Tiny fleur de lis charm

Beads – Gold, pearl, amber crystal,
stone

26" sheer gold ribbon

Gold jump rings

Gold head pins

Tools & Other Supplies:

See the list of Basic Supplies at the
beginning of this chapter.

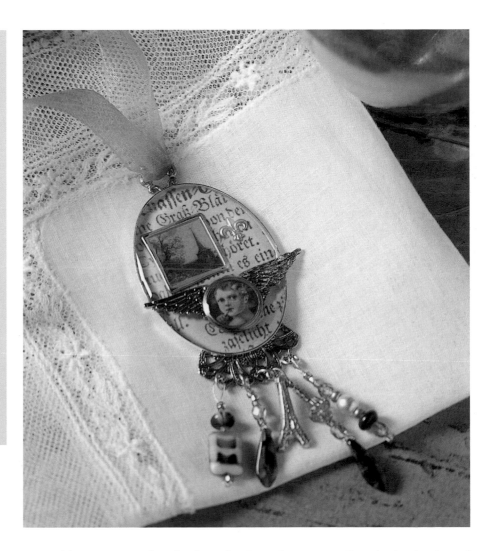

Assemble as instructed under "Jewelry Basic Instructions" at the beginning of
this chapter.

Silver Sweetheart
PENDANT NECKLACE

Cherub and flower charms and rosy beads accent this silver pendant on a cord. Collage papers are used in three bezels in different sizes and shapes. To assemble, follow the Basic Instructions at the beginning of this chapter.

SUPPLIES
Collage Elements:
Rectangular silver bezel with top ring, 2" x 5/8"

Oval silver bezel, ½" x 5/8"

Round bezel with ring, ½"

Collage papers – Cherub, thermometer, couple

Charms – Open petal daisy, silver heart, cherub, open heart and rose

Beads – Red, pink, ivory

Silver head pins

Silver jump rings

Black satin cord, 26" long

Tools & Other Supplies:
See the list of Basic Supplies at the beginning of this chapter.

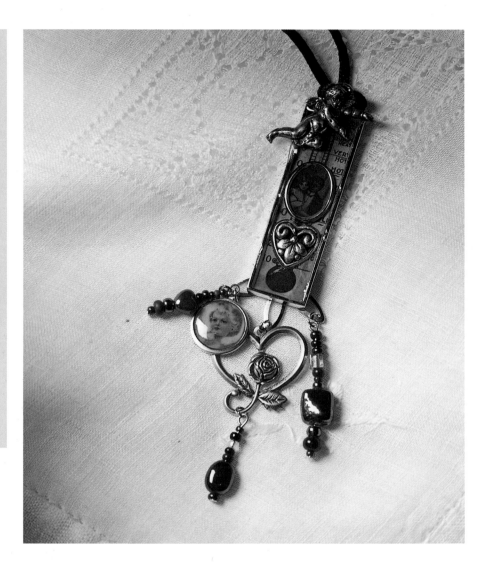

Assemble as instructed under "Jewelry Basic Instructions" at the beginning of this chapter.

Altered Art Collage

Altered art collage takes its name from the idea of altering a surface with papers and embellishments. Altered art takes collage to an exuberant, creative space. The surface altered most often is books — both on the covers and on the pages. In this chapter, I also used artificial fruit and small bottles as bases for altered art.

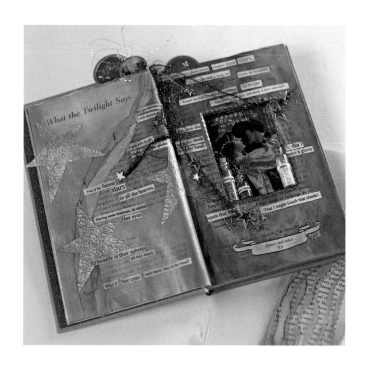

Romance Novel
ALTERED BOOK

The International Society of Altered Book Artists defines an altered book as "a book, old or new, that has been recycled by creative means into a work of art. They can be...rebound, painted, cut, burned, folded, added to, collaged in, gold-leafed, rubber stamped, drilled or otherwise adorned...." There are many different techniques for altering books. This section shows you how to get started, and includes instructions for some of my favorite techniques and a project example.

I used the title of the original book *What the Twilight Says* and a passage from Shakespeare as the theme and inspiration. The collage was designed to be displayed standing up in front of a candle to show off the reflective qualities of the paints and embellishments. I painted the pages with sparkling watercolors. You could substitute plain watercolors or acrylic paints thinned with a transparent medium.

SUPPLIES

Base:

Hardcover book, 6" x 9", with pages at least ¾" thick

Papers:

Dark blue paper with stars

Decoupage paper with Romeo and Juliet motif

Computer-generated poem printed in black and white using a variety of fonts and type sizes

Silver paper stars, 2½" x 3½"

Embellishments:

Silver star stickers

Silver star border stickers

Moon sticker

Small glass vials with cork stoppers

Glitter – Silver, iridescent

Silver bullion

Clear rhinestone stickers

Blue decorative threads

Round metal-rimmed tags, two 1", one 1½"

Tools & Other Supplies:

Silver metallic paint

Colored chalks – Light blue, dark blue

White glue

Sparkling watercolors – Blue, dark blue, light blue, purple

Large clips *or* clamps

Craft glue

Glue stick

Art knife and ruler

Pencil

Wax paper

Collage papers

Collage supplies

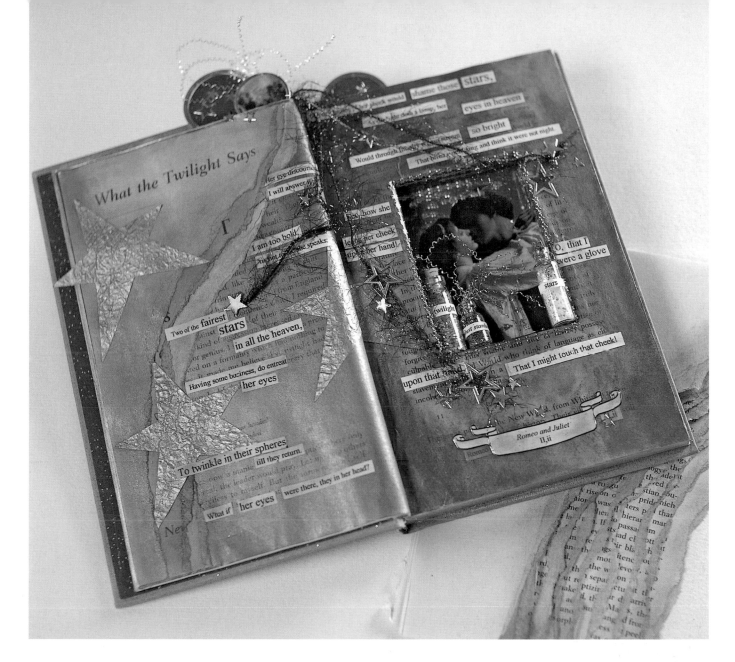

Finding a Book to Alter

To start, you need to get over the fact that you are vandalizing a book. This concerned me greatly until a librarian told me that thousands of books are destroyed each year because they are old and damaged. You do not want to alter a first edition or an expensive book. Instead, save a book from the landfill by buying from library sales or flea markets. I like a book with a hard cover, pages at least ¾" thick, and an interesting title that can be used as inspiration. Children's board books are also a popular base for altered book collage. Board book pages are generally painted with gesso before adding color and embellishments to each page.

INSTRUCTIONS

Prepare the Torn Pages:

These torn pages decorate the left side of the collage. If you're using the book title as your theme, be sure the title shows on the top page.

1. Use an art knife to remove the first three or four pages of the book.
2. Clip the pages together where they were attached to the spine. Rip the top page in half at an angle, leaving

Continued on next page

Romance Novel, continued

the title showing. Rip the other pages so each is a bit larger and follows the line of the previous tear.

3. Separate the pages and paint them with sparkling watercolors. Let dry. Glue the pages together with the glue stick, using the photo as a guide. Set them aside.

Cut a Display Box:

Cutting a display box into the pages of a book is a wonderful way to include three-dimensional embellishments and small collages in your altered book design. You can cut a shallow or deep box, depending on what you want to put in it.

1. Take about 20 pages from the beginning of the book and clamp them to the front cover.
2. With a pencil and ruler, measure and mark a 2½" x 3½" rectangle in the middle of the top page on the right hand side.
3. Make sure the pages are even, then start cutting out the display box in the pages. Cut right down to the back cover. Use a sharp art knife and ruler and start cutting through the pages a few at a time – don't try to cut all the way down at once. Move around the box sides as you work for an even cut. *Option:* If you have problems making clean, even cuts, try clamping and gluing the page edges together. Cut when the glue has dried.

Paint the Display Pages:

1. Place a piece of wax paper under the first display box page. (Wax paper prevents the paint from seeping through and marring other cut pages.) Paint this page with sparkling watercolors. Use all the paint colors on the page, blending them together, and apply them thinly so the text of the book shows through.
2. Place a piece of wax paper under the top left hand page and paint to match the display box page.

Glue the Page Groups & Paint:

1. Turn the right hand painted page over to the left hand side. Clamp the remaining box pages together tightly. Brush white glue on the top, side, and bottom edges of the pages. (This layer of glue will hold the pages together permanently.) Let dry completely. *Option:* Brush glue on the page edges inside the display box. Let dry completely.
2. Turn the painted right hand page back to the right side. Turn the painted left hand page over to the right hand side. Clamp the pages on the left hand side together and brush white glue on the top, side, and bottom edges of

the pages. Let dry completely. Remove the clamps.

3. Paint the edges of the left and right hand page groups with silver metallic paint. TIP: Use wax paper to avoid getting paint on the covers.

Glue the Prepared Pages:

1. Cut the dark blue paper to fit the inside of the front cover. Glue in place with the glue stick.
2. Decide whether you want to glue the pages so the book lies flat (for displaying open and flat) or at an angle (for displaying open and standing up).
3. Glue the display box pages to the inside back cover with white glue.
4. Glue the left hand page group to the left inside cover with white glue. Clamping to hold while drying.

Line the Display Box:

Lining a display box with decorative paper highlights it and hides any imperfect cuts. You can use these instructions for lining a box of any size or depth.

1. Cut a piece of dark blue decorative paper 4½" x 5½".
2. Use a ruler and bone folder to measure and score the lines, following the Cutting Diagram (Fig. 1). Fold along the scored lines and trim off the corner pieces.
3. Rub a glue stick on the back of Area A and place the card stock inside the cutout display box. Use the bone folder to burnish the card stock and push it into the corners.
4. Turn the top page of the display box and clamp it to the opposite side of the book. TIP: If you are using a dark-colored lining paper, lift and turn two or three pages so the flaps won't show through.
5. Add the glue to the C flaps and glue them over the page that is now on top.
6. Unclamp the page(s) you turned and glue them over the C flaps.

Create the Collage:

1. Glue the painted pages to the left and right hand sides with the glue stick.
2. Glue on the ripped pages to the left hand painted page.
3. Glue the large silver stars to the left hand page with the glue stick.
4. Cut the poem into strips. Glue into place on the painted pages. *Option:* Add a label (as I did) at bottom of the display box page that contains the source of the poem.
5. Use chalk to color the stars and poem strips.
6. Cut out the Romeo and Juliet image and glue in the display box.

7. Add silver star border stickers inside and around the edges of the display box. Add rhinestone stickers inside the display box.

8. Fill the glass vials with glitter and label with computer-generated labels (e.g., "stardust," "twilight," and "star.") Use white glue to adhere corks or silver bullion bows in the tops.

9. Use white glue to adhere the vials in the display box.

10. Cut pieces of decorative threads and glue the ends into the top of the book's spine. Glue in place on the pages, using the photo as a guide, and add silver star stickers to the ends.

11. Glue dark blue decorative paper circles to two of the tags. Add silver star stickers to embellish. Put the moon sticker on the remaining tag.

12. Using an art knife, cut a slits in the tops of the glued pages and insert the tags. Secure with a few drops of white glue in the back.

13. Add a silver bullion bow behind the tags for extra sparkle. ❏

Fig. 1 – Cutting Diagram for Lining a Display Box

Legend

• Dashed lines are fold lines.

• Shaded areas are cut and removed.

• Area A is the size of the display box you cut into the pages.

• Flaps B are the depth (thickness) of box.

• Flaps C are leftover paper. They should be at least ½" wide.

Renaissance Pears

DISPLAY ART

Line up these elegant pears on a shelf or mantel – they make charming Olde World accents. Using foam-type artificial pears makes it easy to attach the embellishments with pins. Gold bullion, the tightly coiled fine wire that is used in floral arrangements and Christmas ornaments, can be found in floral and crafts shops.

SUPPLIES

For one pear

Base:

Artificial foam pear, 3½" wide, 4" tall

Papers:

Gold-printed tissue *or* mulberry paper

Patterned decoupage tissue with script lettering

Gold tissue

Embellishments:

Sequin stickers

2 pink flower blossoms

1 velvet leaf

1/3 yd. gold wire-edge metallic ribbon, ⅜" wide

Gold bullion

3 gold leaf charms

Beads – Amber, copper, gold

Gold tags, ¾" – Oval, round, rectangular

Renaissance image stickers

1 twigs (for the stem)

Tools & Other Supplies:

Gesso

Acrylic paint – Light peach

Pliers

Decoupage medium

Walnut ink in a spray bottle

Clear dimensional varnish

Large gold-topped pins

Small gold pins

Gold beading wire

Craft glue

Sharp pencil

Collage supplies

INSTRUCTIONS

Replace the Stem:

1. Remove the plastic stem from the pear, using pliers.
2. Dip the end of the twig in craft glue and place in the top of the pear. TIP: If needed, use a sharp pencil to make the hole for the stem larger.

Start the Collage:

Use the twig as a handle when painting and gluing.

1. Coat the pear with gesso. Let dry.
2. Basecoat with peach acrylic paint. Let dry.
3. Tear the printed tissue or mulberry paper into 3" pieces. Apply with decoupage medium to cover the entire surface of the pear.
4. Tear the script lettering tissue into 2" pieces. Apply randomly to the pear, using decoupage medium. Let dry.
5. Add the sequin stickers to the pear for sparkle.
6. Remove the plastic parts from the flower blossoms. Spray the blossoms with diluted walnut ink to antique. Let dry.
7. On a large gold-topped pin, thread a bead, a flower blossom,

Continued on page 72

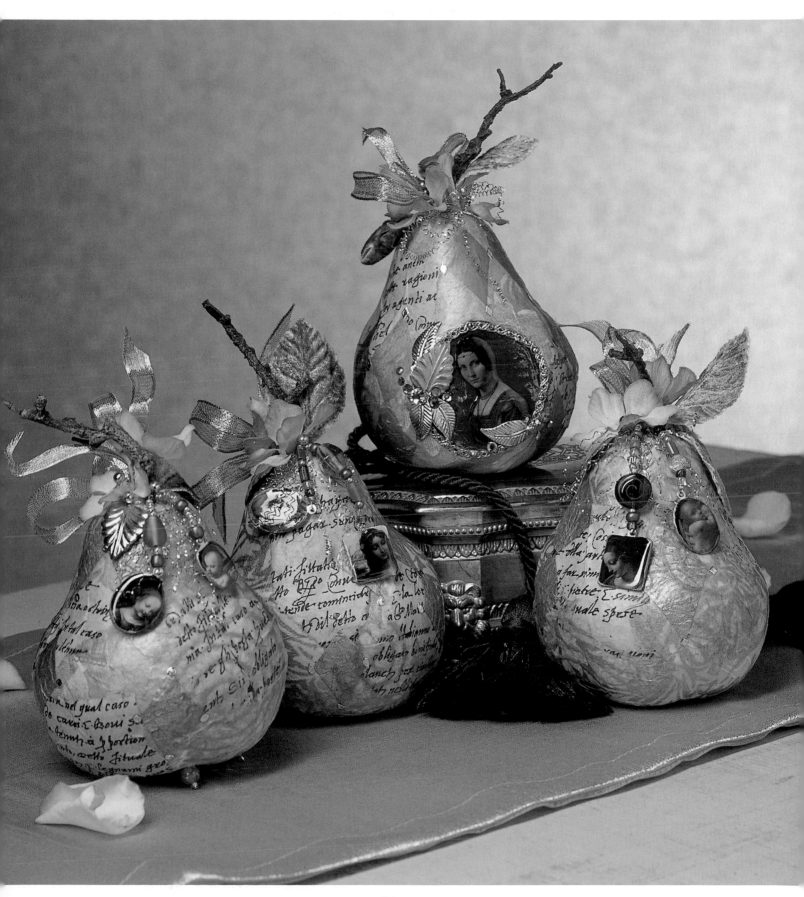

Renaissance Pears, continued

and another bead. Push into place at the top of the pear. TIP: For a more secure hold, dip the end of the pin holding embellishments in craft glue before pushing it into the pear.

8. Thread another pin with a bead, a flower blossom, and several beads. Push it into the pear. (The added beads add height to this blossom.)

Embellish:

1. Place the Renaissance image stickers on the small tags. Trim to fit.
2. Cover the images on the tags with clear dimensional varnish. Let dry completely.
3. Thread each tag on a 6" piece of beading wire and fold in half. Thread both ends through a selection of beads, varying the lengths from 1" to 1 ¾" long.
4. Wrap the beading wire ends of two tag-and-bead embellishments around the top of a gold pin. Push the pin into the top of the pear.
5. Make a four-loop bow with gold wire-edge ribbon. Attach at the top of the pear with a pin.
6. Attach the velvet leaf and gold leaf charms with gold pins.
7. For additional sparkle, Cut 4" of gold bullion. Pull and form into a loopy bow. Twist to hold in the center. Attach the bow with a pin.
8. *Option:* Make a beaded foot (or feet). One of my finished pears would not sit upright – it kept falling over. I made a tiny "foot" to help the pear stand up by threading a bead on a headpin and pushing it in the bottom. ❏

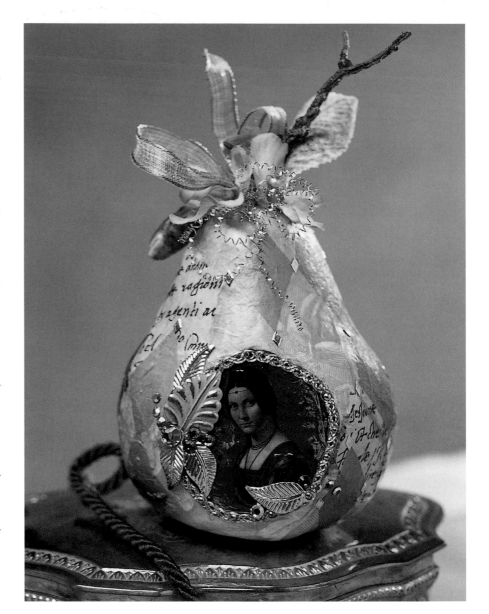

Variation: Portrait Pear

Because the pears are made of foam, it's easy to slice off a piece and use the cut area for a sticker image. Here's how:

1. Use a serrated knife to cut off a piece of the pear.
2. Paint the cut area with gesso. Let dry.
3. Basecoat the cut area with dark brown acrylic paint. Let dry.
4. Trim a sticker image to fit the cut area and adhere.
5. Coat with clear dimensional varnish. Let dry.
6. Embellish with gold leaf charms, rhinestones, and gold metallic braid, attaching the embellishments with craft glue and small pins. ❏

Artistic Assemblage Display Art

Pattern
(actual size)

Instructions begin on page 74.

Artistic Assemblage
DISPLAY ART

This altered art piece, designed to hang on the wall or sit on a tabletop easel, is funky and fun. Art is the theme. I used a plastic palette as a base, but you could cut out the shape from a piece of mat board using the pattern provided. The background of the collage is washi paper. The term washi refers to any Japanese paper ("wa" meaning "Japan," "shi" meaning "paper.")

SUPPLIES

Base:

Plastic palette, 8½" x 6½" (Or cut from mat board.)

Ruler, 8" long (cut from an old wooden yardstick)

Natural bristle paint brush, 2"

Wooden artist's mannequin, 4" tall

Papers:

Cream washi paper

Art saying

Art images

Decal transfer film

Embellishments:

Copper letters – ART

Metal stencil letters – ART

Found jewelry piece – Paint palette

Metal rick rack brads

2/3 yd. red grosgrain ribbon, ⅜" wide

Tools & Other Supplies:

Gesso

Acrylic paints – Red, yellow, blue

Acrylic gel stain – Dark brown

Sandpaper, 300 grit

Metal paint – Dark brown,

Metallic wax – Turquoise

Inkpad – Vintage sepia

Stencil brush

Decoupage medium

Matte varnish

Clear dimensional varnish

Scissors

Small finishing nail and hammer

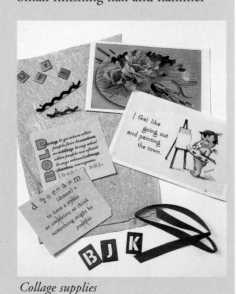

Collage supplies

INSTRUCTIONS

1. Cover the palette with washi paper, using decoupage medium to adhere the paper. Trim the excess paper on the edges to ½", then clip and fold the paper over the edges of the palette and again adhere with decoupage medium. Let dry.

2. Use the art saying paper and the art images paper to make decal transfer images. See the "General Information" chapter for instructions.

3. Attach the images to the palette, overlapping them and trimming as necessary.

4. Antique the edges of the palette with sepia ink, using a stencil brush.

5. Coat the palette with a layer of clear matte varnish. Let dry.

6. Apply the puddles of paint to the palette along one side, using the photo as a guide for placement. Blend and mix the colors as you go, from red to orange, yellow, green, and blue. Let dry completely.

7. Cover the paint puddles with clear dimensional varnish. Let dry.

8. Antique the wooden ruler, the

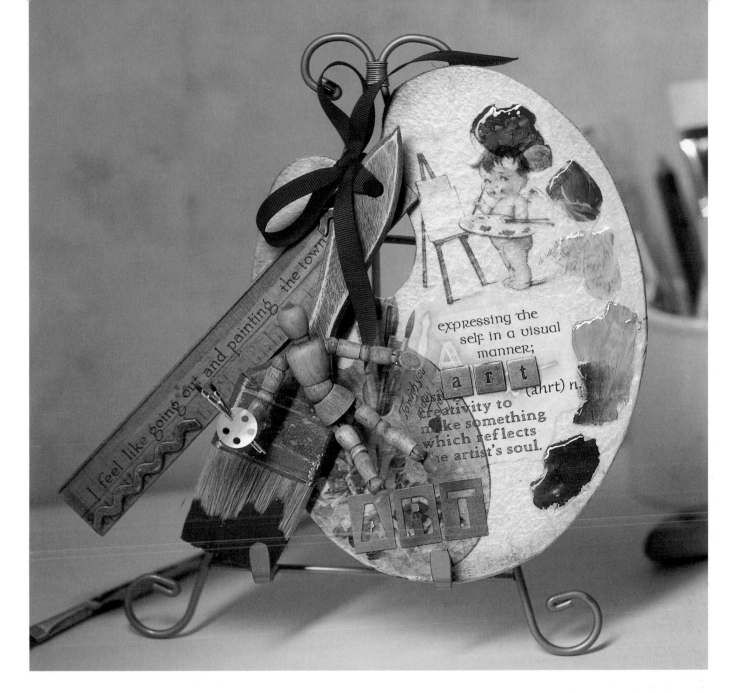

paint brush handle, and the artist's mannequin with brown gel stain. Work one small area at a time, wiping off the stain as you go. Let dry.

9. Distress the stained wooden pieces with sandpaper. Wipe away the sanding dust.

10. Apply a rusted metal painted finish to the metal ferrule of the paint brush. See the "General Information" chapter for instructions.

11. Dip the ends of the bristles of the paint brush into red acrylic paint. Let dry.

12. Highlight the dry red paint with a coat of clear dimensional varnish.

13. Add a quotation or saying to the ruler by creating a decal transfer using computer-generated lettering. Mine says, "I feel like going out and painting the town red."

14. Use craft glue to attach the metal embellishments to the palette and ruler.

15. Attach the mannequin's backside to the wooden paint brush handle with craft glue and a small nail. (This allows you to pivot the mannequin to a sitting or standing position.)

16. Tie the ruler and paint brush (with the mannequin attached) to the palette with red ribbon. ❏

Message on a Bottle
ALTERED BOTTLES

These altered bottles are embellished with inspirational words – they'd be great gifts for a friend or co-worker whose spirits need a lift. I filled the mini bottles with small pieces of copper leaf. You could substitute colored sand or metallic powder.

SUPPLIES

Base

Small glass bottles with tops

Papers:

Sheet music

Rub-on transfers – Inspirational words, musical instruments

Embellishments:

Paper flower, 1" – Peach, taupe, or tan (1 per bottle)

Copper brad (1 per bottle)

Decorative fibers, 12" lengths – Rust, turquoise

Vintage tag

Metallic copper word sticker

Miniature bottle with copper leaf and cork stopper

Tools & Other Supplies:

Spray paints – Antique gold, black

Masking tape

Inkpad – Sepia

Stencil brush

Metal paints – Dark brown, burnt sienna

Metallic wax – Turquoise

Decoupage medium

Craft glue

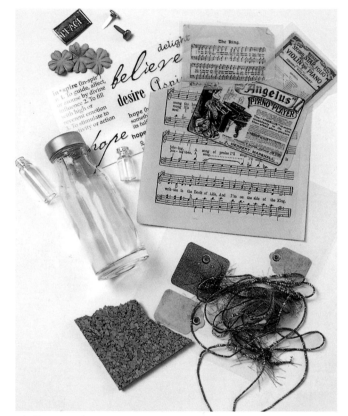

Collage supplies

INSTRUCTIONS

Prepare:

1. Wrap the masking tape around the threads on the necks of the bottles to protect them while spray painting.
2. Spray the bottles with gold paint. Spray the lids with black paint. Let dry. Remove the tape and attach the lids.

Make the Collage:

1. Cut a piece of sheet music to fit the front of the bottle. Tear along the bottom edge.

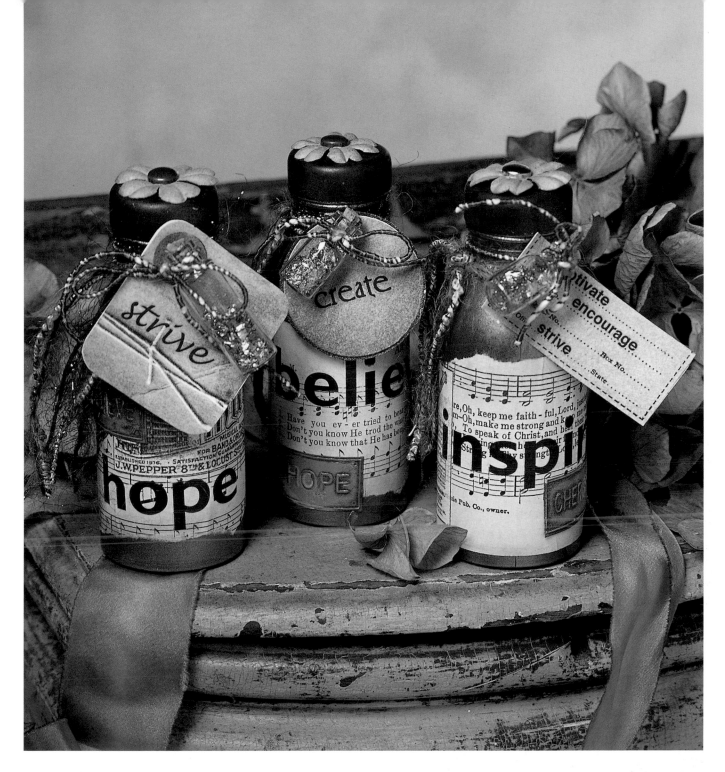

2. Antique all the edges of the sheet music piece with sepia ink, using a stencil brush.

3. Use decoupage medium to adhere the sheet music panel to the bottle.

4. Rub on the inspirational word and music motifs. Rub words on the vintage tags.

5. Apply a verdigris patina finish to the metallic word sticker. See "Verdigris patina" in the "General Information" chapter.) Let dry. Attach to the bottle.

6. Attach the vintage tag and miniature bottle to the neck of the bottle with decorative fibers.

7. Thread the copper brad through the paper flower. Open the prongs on the back and flatten. Use craft glue to attach it to the top of the lid. ❑

CHAPTER 7

Photo Collage

Collages are a wonderful way to display photographs, and they provide opportunities to combine photographs in interesting ways. Digital photography and specialized printers for photographs make it easy to make multiple prints on different types of papers. You can also make photocopies of photographs to use in collages, preserving your originals.

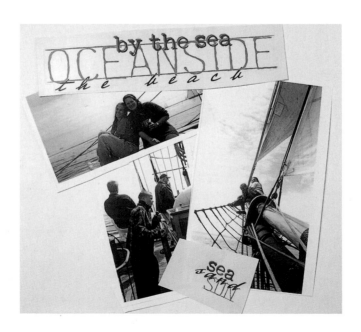

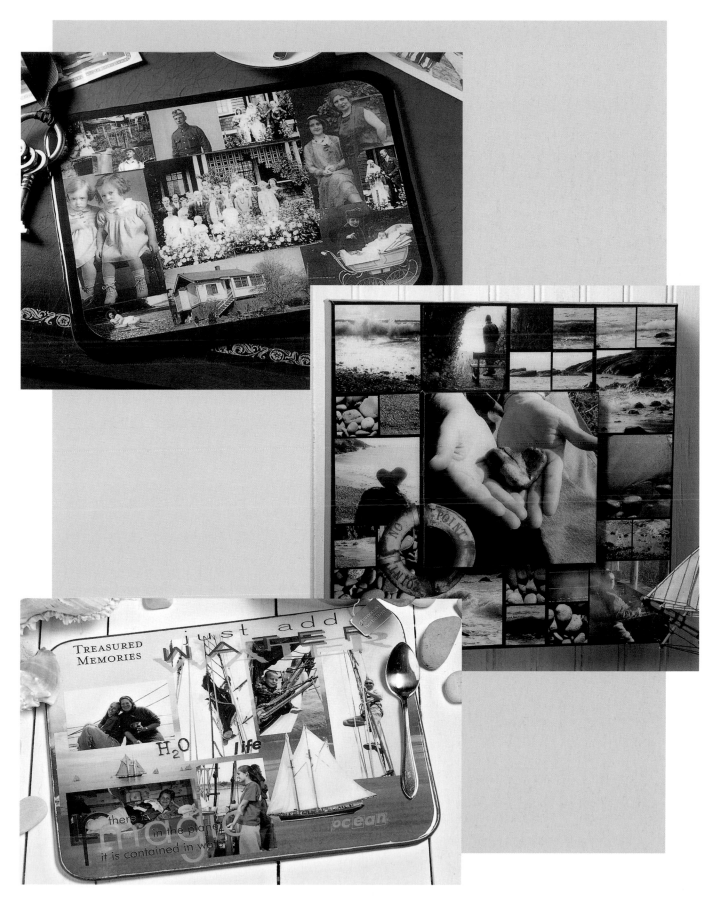

Point No Point
PHOTOMONTAGE

Photographs from a vacation, canvases, and foam core board create a modern display.
With a high-gloss polymer coating, this collage takes on the appearance of glazed tiles.

SUPPLIES

Base:

Stretched canvas, 12" x 12" x 1½"

Canvas board, 12" square

Foam core board, ½" thick, 6" square

Papers:

1 photograph, 6" square, cropped from an 8 x 10 print

10 photographs, 4" x 6"

1 cutout motif (lifesaver)

Tools & Other Supplies:

Acrylic paints – Gray, black

Paper trimmer

White glue

Basic supplies for polymer coating (See the "General Information" chapter.)

INSTRUCTIONS

1. Glue the foam core panel to the exact middle of the canvas board, using craft glue. Weight the panel with a heavy book until dry.
2. Basecoat the canvas board (with the attached foam core tile) with black acrylic paint, covering all the edges.
3. Basecoat the stretched canvas with gray acrylic paint. Set aside to dry.
4. Crop the 4" x 6" photos to make eight 3" squares and sixteen 1½" squares.
5. Arrange the cropped photos on the canvas board, using the project photo as an example for placement. When you are happy with the design, glue the photos in place with thin-bodied white glue, leaving a small space between each photo.
6. Cut the lifesaver motif into two pieces to accommodate both the foam core tile and the canvas board. Glue in place for an interesting dimensional effect.
7. Following the instructions in the "General Information" chapter, coat the canvas board with polymer coating. When the coating stops dripping off the edges (about one hour after application), carefully lift the coated canvas board and place it on the gray stretched canvas. (The coating will bond the canvas pieces together.) Check periodically to make sure the canvas board stays in place squarely, without shifting. Let cure completely. ❏

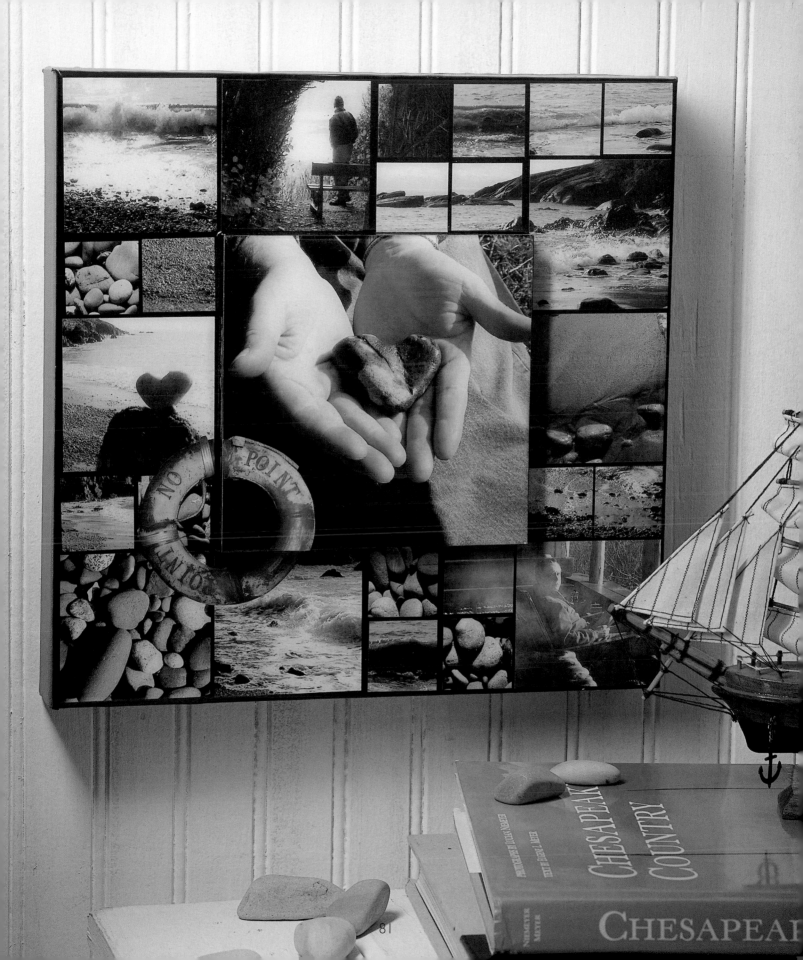

A Dinner to Remember
PHOTO PLACEMATS

Placemats covered with photographs and finished with a protective polymer coating make wonderful, meaningful gifts for family and friends. I've created three different versions to give you ideas for designing your own placemats. Wooden placemats are easy to find at gift and dollar stores. Simply paint over the image with gesso and add your photo design.

BASIC SUPPLIES

Base:

Wooden placemat with cork backing, 8½" x 11½"

Other Supplies:

Gesso

Acrylic paint *or* decorative paper and 300-grit sandpaper

Photographs and paper images

Decoupage medium

Basic supplies for polymer coating (See the "General Information" chapter.)

BASIC INSTRUCTIONS

1. Paint the top of the placemat with gesso. Let dry. Add additional coats until the image no longer shows through. Let dry.
2. *Either* basecoat with an acrylic paint and let dry *or* cover the mat with decorative paper, using decoupage medium. Let dry and sand off the edges of the paper to trim it flush with the mat.
3. Crop and trim the photographs and paper images to fit the mat and arrange them to suit. Adhere to the mat with decoupage medium.
4. Coat the entire surface with two thin coats of thin-bodied white glue to seal. Let dry completely.
5. Following the instructions in the "General Information" chapter, apply a polymer coating to protect the mat. Let cure completely. ❑

Undecorated mat

Vintage Photos Placemat

The photographs were arranged on a 8½" x 11" sheet of paper and color photocopied. The base mat was painted with dark brown acrylic paint. The corners of the montage copy were trimmed to fit the base and decoupaged to the surface. To make the placemat, follow the Basic Instructions at the beginning of this section.

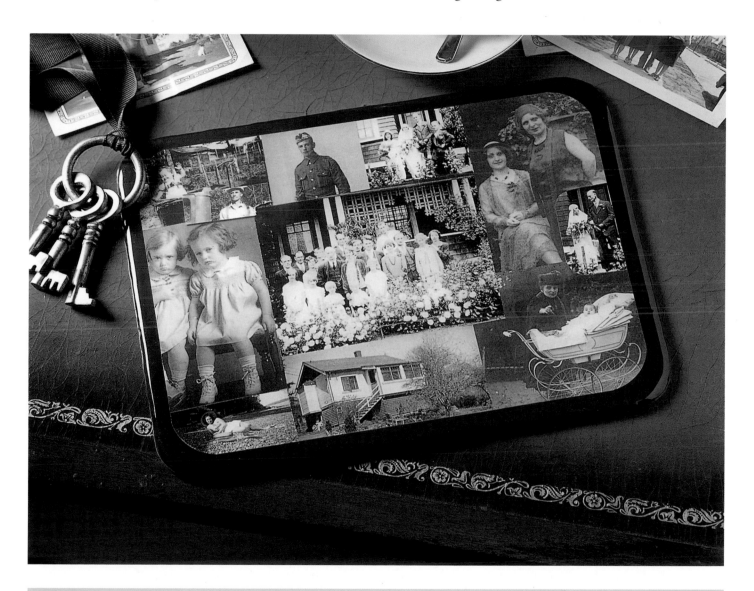

SUPPLIES

Placemat with cork backing

Gesso

Acrylic paint – Dark brown

Vintage photographs

Decoupage medium

Basic supplies for polymer coating (See the "General Information" chapter.)

Sail Day Placemat

One photograph, a sea scene, was enlarged and adhered with decoupage medium as the background. The other photographs were cropped and glued in place; transparent wording overlaps and accents the photos. To make the placemat, follow the Basic Instructions at the beginning of this section.

SUPPLIES

Placemat with cork backing

Gesso

Acrylic paint – Dark brown

Large color photocopy of photograph

Color photocopies of photographs

Transparencies – Sea saying and quotation stickers on clear backing

Decoupage medium

Basic supplies for polymer coating (See the "General Information" chapter.)

Collage supplies

Postcards from Paris Placemat

A map of France (from gift wrap) was decoupaged on the mat as a background. Vintage postcards, postage stamps, and other paper images that fit the "Postcards from Paris" theme were layered and adhered with decoupage medium. For an antique effect, crumple some of the paper pieces and stain with tea. See the "General Information" chapter for instructions. To make the placemat, follow the Basic Instructions at the beginning of this section.

SUPPLIES

Placemat with cork backing

Gesso

Acrylic paint – Dark brown

Antique map of France (on gift wrap)

Vintage postcard images (fronts and backs)

French postage stamps

Images to fit theme

Decoupage medium

Basic supplies for polymer coating (See the "General Information" chapter.)

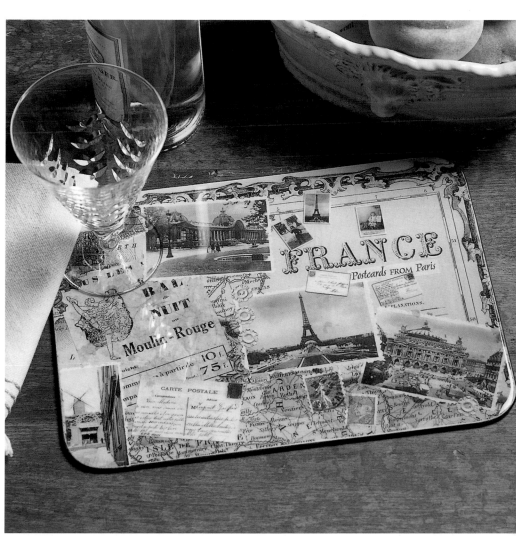

Pictured left: collage supplies

Beeswax Collage

This collage technique uses melted beeswax to adhere and protect the collage elements. Beeswax collage is perfect for beginners because it's easy to adjust and change the collage by re-heating the beeswax and moving the elements.

Wax is an excellent preservative. (The Ancient Greeks applied melted wax and natural resins to weatherproof and decorate their ships.) It is impervious to moisture and will not deteriorate, making the finished collage long lasting. The wax imparts a beautiful amber luster and a lovely honey aroma. As it takes a thousand flowers to make one ounce of beeswax, your beeswax collage is a tribute to your talents and to the thousands of bees and flowers who produced the wax.

Beeswax collages can be made on heavier-weight papers, canvas boards, or other rigid surfaces such as candles. You will need about four ounces of beeswax for each square foot of collage.

BE SAFE! Wax is flammable. **Always** use this double-pan system when melting wax to reduce the risk of fire. **Never** leave the room while melting or using the wax.

Beeswax Collage Technique

Basic Supplies

A rigid surface (for the base)

Thin papers (for the background)

Collage papers and/or stickers

Embellishments (e.g., dried flowers, dried leaves, or charms)

100% pure beeswax, 4 oz. per square foot

Natural bristle brush, ½" to 1"

Electric frying pan and container, such as a foil container or an old saucepan

Embossing heat gun *or* tiny quilting iron

Soft, lint-free polishing cloth

Optional: Masking tape (if you're using a paper base)

Basic Instructions

Prepare:

1. Place beeswax in the old saucepan or foil container.
2. Place the container with beeswax in the frying pan. Pour at least 1" of water around the container. Add more water while you work as needed – the water should always be 1" deep.
3. Place the collage base on a smooth wooden board. If your base is paper, tape it to the board to prevent warping.
4. Brush the base with a layer of beeswax. If it hardens, that's okay. Don't worry when the brushed wax turns a creamy, opaque white color – as it hardens and cools, it will become translucent and amber in color.

Create the Collage:

1. To create the background, layer thin handmade papers, the printed layer of paper napkins, or tissue paper. The background papers will be translucent, creating some interesting effects as you add layers. Lay the paper pieces on the base and brush each piece with melted beeswax as you apply it. Keep adding paper pieces until the entire base is covered. If appropriate for your base, wrap the papers around the edge of the base and use wax to hold the papers in place.
2. Add the collage papers and/or stickers over the background, coating everything with wax.
3. Place the embellishments and brush with melted wax to cover. Allow to cool completely. (This may take as long as an hour.)

4. Assess your collage. If you don't like the placement of a paper piece or embellishment, heat the area with a heat gun or small iron, and remove and replace the piece. CAUTION: You can easily burn, scorch, or melt papers and embellishments with a heat gun so keep it at least 3" from the surface and constantly moving.

Finish:

1. When the collage is finished, smooth the wax (removing the brush strokes) by heating the surface gently with the heat gun to melt the wax. Let cool and harden completely. Let the brush and wax harden for your next beeswax collage project. The brush will soften when heated again.
2. Polish the surface of the wax with a soft cloth. **Note:** Pure beeswax sometimes develops a white powdery surface (called "bloom") over a period of time, especially if stored in a cool area. The bloom is your assurance of the purity of the wax. It can be removed by polishing the surface with a soft cloth or by heating gently with a hair dryer. ❑

Decorative Options

- **Add color with metallic wax.** Metallic wax can be applied with your finger to any area where you want soft metallic color, then buffed with a soft cloth to a sheen. Metallic wax comes in a wide variety of colors and can be added at any point in the process to make interesting layers of color.

- **Add color with crayons.** Metallic wax crayons and ordinary wax crayons can be used to add color to wax collages by placing thin crayon shavings on the collage. Use a quilting iron to melt and blend the color into the beeswax. TIP: If you add too much color, scrape off the melted crayon with the iron and smooth again.

- **Stamping the wax.** You can add texture to the surface of a wax collage by stamping the soft wax with rubber stamps.
 Here's how: Smooth and melt the area to be stamped with an embossing gun. When the wax is cloudy but still warm, press the stamp into the wax. It will leave an impression. If you are unhappy with the results, reheat the area and stamp again. To enhance the stamped image, use metallic wax to color the area around the stamping.

Joy without End

WALL SIGN

Artificial berries and silk leaves add dimensional touches to this beeswax collage. The depth and luster of the wax over the transparent napkin motifs lends a beautiful olde world charm. "Joy-Sans-Fyn" is Latin for "Joy without End" – the translation is added to the border. Other sayings that could be used for a sign collage include: "Casa Sweet Casa," "Enjoy Life – It's delicious!" or "Live the good life!"

SUPPLIES

Base:

Wooden sign with arched top, 22" x 11"

Papers:

Paper napkins – Gold filigree, red berries, blackberries

Embellishments:

Silk leaves

Artificial black and red berries

Copper butterfly charm

Tools & Other Supplies:

Rubber stamps – 1½" alphabet, ½" alphabet

Permanent inkpad (for slick surfaces) – Olive green

Metallic wax – Gold

Basic supplies for beeswax collage (See the beginning of this chapter.)

Collage supplies

INSTRUCTIONS

1. Carefully remove the top printed layers from the paper napkins. You need five gold filigree napkins, three red berries napkins, and three blackberries napkins.
2. Tear the napkins into quarters. Tear all the straight edges off the napkins so there are no sharp, cut edges.
3. Brush a layer of beeswax on the sign, covering the inside panel and rim completely.
4. Apply the gold filigree napkin pieces to cover the sign, tearing them into smaller strips to cover the rim. As you work, push the napkin pieces into the corners and over to the back of the sign.
5. Using the photo as a guide, add the berry designs to the inside panel. I placed red berries on one side and blackberries on the other, with the gold

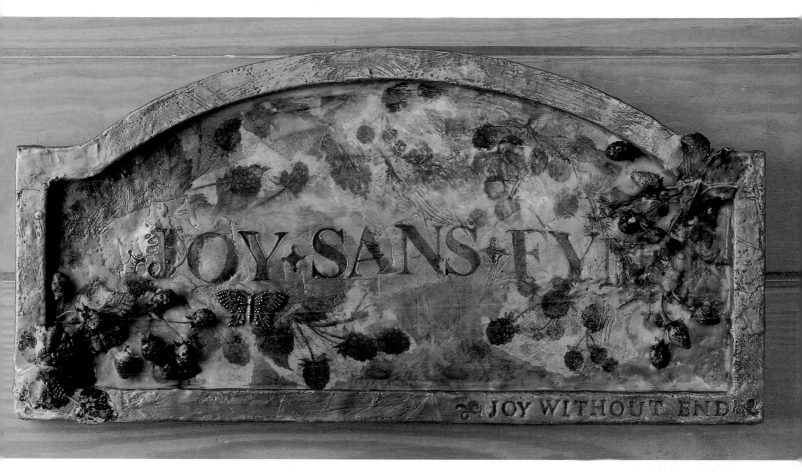

filigree pattern showing in the middle.

6. Using beeswax, add the silk leaves, berries, and charm. Coat with a layer of beeswax to hold and make them blend into the design.

7. Add a few additional layers of beeswax to the center of the sign and rim where the letters will be stamped.

8. Stamp the letters of the saying on a piece of paper and cut out in a strip. Use the strip as a guide to help you space the lettering while stamping the sign.

9. Heat the wax with an embossing gun to soften. Ink the stamp well and stamp each letter in the soft wax. Use the 1½" letters for the center and the ½" letters on the border. Let the wax cool and harden completely.

10. Rub gold metallic paste around the lettering and the entire rim. If you get wax on the letters, stamp again to cover the wax. When dry, buff the surface of the sign with a soft cloth. ❑

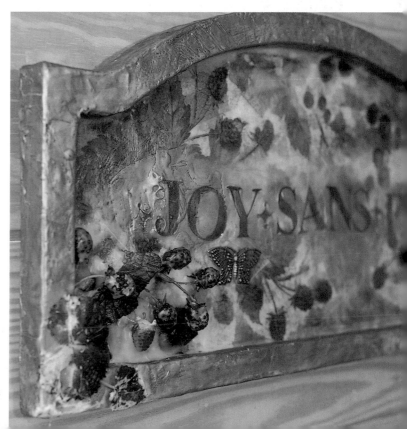

Artistic Greetings

DECOLLAGE CARDS

An interesting background is created when torn decorative papers (the technique is called "decollage") are coated with beeswax. Stamped images and beads pressed into the wax complete the panels, which can be cut for greeting or artist trading cards (ATC).

SUPPLIES

For the Collage Panels:

Base:

Lime green card stock, 12" square

Papers:

Decorative paper sheets in coordinating colors, 12" square – Purple damask, green and blue, large floral

Transparencies – Friend quotation stickers on clear backing

Embellishments:

Seed beads – White, pearl

Flower-shaped beads

Bugle beads

Tools & Other Supplies:

Craft glue

SUPPLIES

Art knife, ruler, and cutting mat

Rubber stamp – Swirl or flourish motif

Awl

Round toothpick

Metallic wax – Emerald, amethyst

Basic supplies for beeswax collage (See the beginning of this chapter.)

For Each Card:

Olive green card stock, 8½" x 5¾"

Decorative paper panel, 5½" x 4¼" (Use one of the papers from the collage.)

Double-sided tape

For Each ATC:

4 gold corner charms

INSTRUCTIONS

Create the Panels:

1. To make the decollage, layer and glue decorative papers to the lime green paper. Use craft glue sparingly, leaving large areas with no adhesive. Let dry.
2. Tear away parts of the top three papers to create the background. Control the tearing, making sure all the layers of paper show.
3. Brush a thin coat of beeswax over the torn paper collage. Let harden.
4. Using an art knife, ruler, and cutting mat, cut the collage into 5¼" x 4" panels for cards and 2½" x 3½" panels for ATCs.

Decorate:

1. Add a clear sticker to each panel and cover with a layer of beeswax.
2. Push beads into the soft wax – you can add just a few beads or more for an elaborate design.
 - Use an awl to quickly and easily pickup and place the seed beads in the wax.
 - For larger beads and bugle beads, use a toothpick with a small amount of wax on the end for easy pick up.
 - Warm and soften the wax with an embossing heat gun, if needed, as you work.
3. Melt the beeswax around the edges of the panels with an embossing gun. Stamp the swirl border with

Collage papers

Supplies

a rubber stamp. Let the beeswax harden.

4. Rub metallic wax around the edges of the panels to accent the stamped texture. Let dry, then buff the surface with a soft cloth.

Finish:

To create the cards: Fold the green card stock to make a card 5¾" x 4½". Use double-sided tape to adhere the finished beeswax panel to the paper panel and card base.

To make ATCs: Add the corner charms to the smaller panels. ❑

Pictured right: card with beeswax applied.

Marking the Spot
PEAT POTS

Peat pots are sold in garden centers for starting plants. They create an interesting base for a collage. Use these decorated peat pots as luncheon party favors or to hold small gifts. Fill them with a small silk plant, candy, or potpourri. Natural handmade papers and images of flowers or vegetables work well with this natural base.

SUPPLIES

Base:

Peat pot, 2½" high x 2¼ wide

Papers:

Decorative handmade paper with a swirly willow design

Tissue decoupage paper printed with fruits and veggies

Paper images of flowers or insects

Embellishments:

Metal label holders (1 per pot)

Garden-theme charms (2 to 3 per pot)

Waxed linen cord (16" per pot)

Tools & Other Supplies:

Basic Supplies for Beeswax Collage (See the beginning of this chapter.)

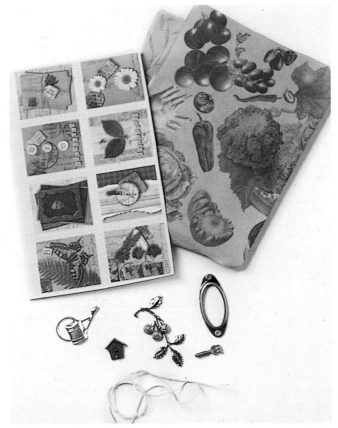

Collage supplies

INSTRUCTIONS

1. Tear the handmade paper into panels to fit each of the four sides of the pot.
2. Brush a coat of beeswax on one side of the pot. Attach a paper panel and brush with wax to hold. Repeat with the process on the remaining three sides of the pot.
3. Cut out fruit and vegetable motifs from the decoupage tissue paper. Add the cutouts to the pot, letting the motifs overlap the corners of the pot.

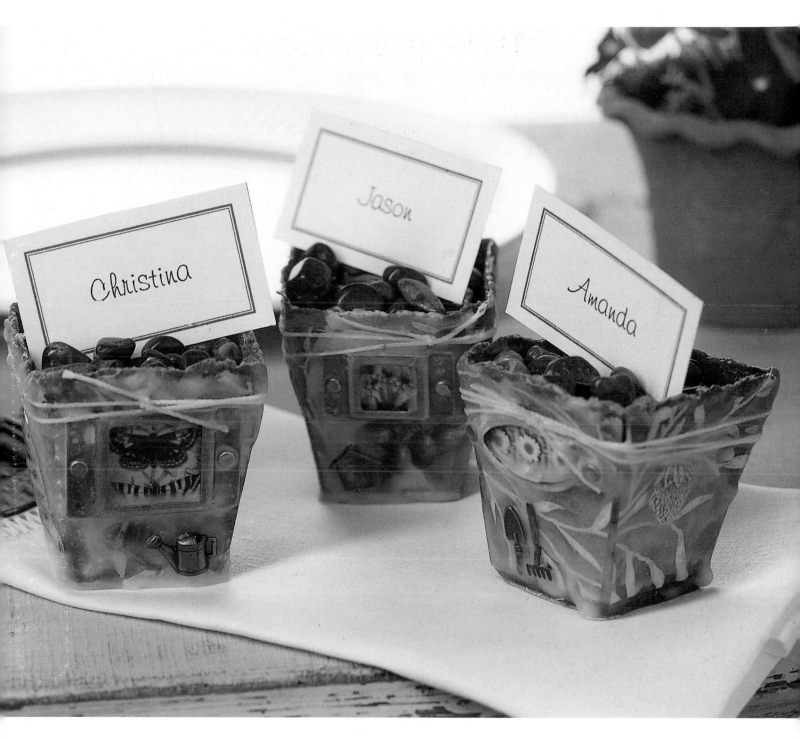

4. Trim a paper image to fit inside the label holder. Attach the image and label holder to the pot panel of the pot with the melted wax.

5. Wrap the linen thread around the pot and knot in the front. Cover with melted wax.

6. Use melted wax to attach the charms to the sides and front of the pot. ❑

Lavender Fields
CANDLES

These pillar candles are covered with paper and dried lavender sprigs – beautiful, but flammable. To avoid accidents, I insert a tea light; I've described the process below. This way, when you light the candle, the flame will melt only the wax in the tea light. To use again, add a new tea light. If you're giving these candles as a gift, make a card with the instructions from step 7 and include it with the candles.

SUPPLIES

Base:
2 cream pillar candles, 2¾" diameter – One 6", one 9"

Papers:
Paper napkins with lavender field scene

Vintage garden labels

Embellishments:
Dried lavender sprigs – 8 to 10 per candle

Green cord, 20" per candle

Tools & Other Supplies:
Basic Supplies for Beeswax Collage (See the beginning of this chapter.)

Lavender tea light (Use one that comes in a clear holder.)

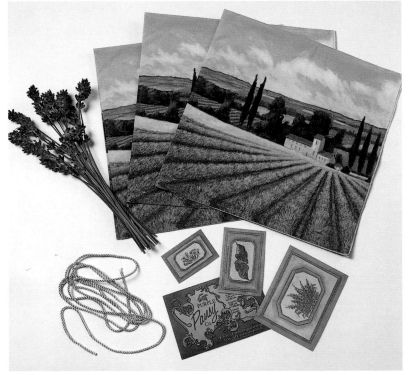

Collage supplies

BE SAFE! **Never** leave a candle burning unattended, and keep lighted candles away from anything flammable, such as draperies.

When the tealight inset candle has burnt down, add a new tealight to protect the candle design.

INSTRUCTIONS

1. Separate the layers of the napkins. Tear the printed top layer to make a panel that fits around the candle. Tear additional pieces of the sky to add around the top of the tall candle. Make sure the top edges of the napkin pieces don't have straight lines.
2. Working one candle at a time, brush a coat of beeswax on the candle and attach the panel, brushing wax over it to hold. Use the photo as a guide for placement. Don't worry about drips – they can be melted away later.
3. Add the labels around the top of the candle.
4. Using melted wax, attach the sprigs of lavender to the front of the candle.

94

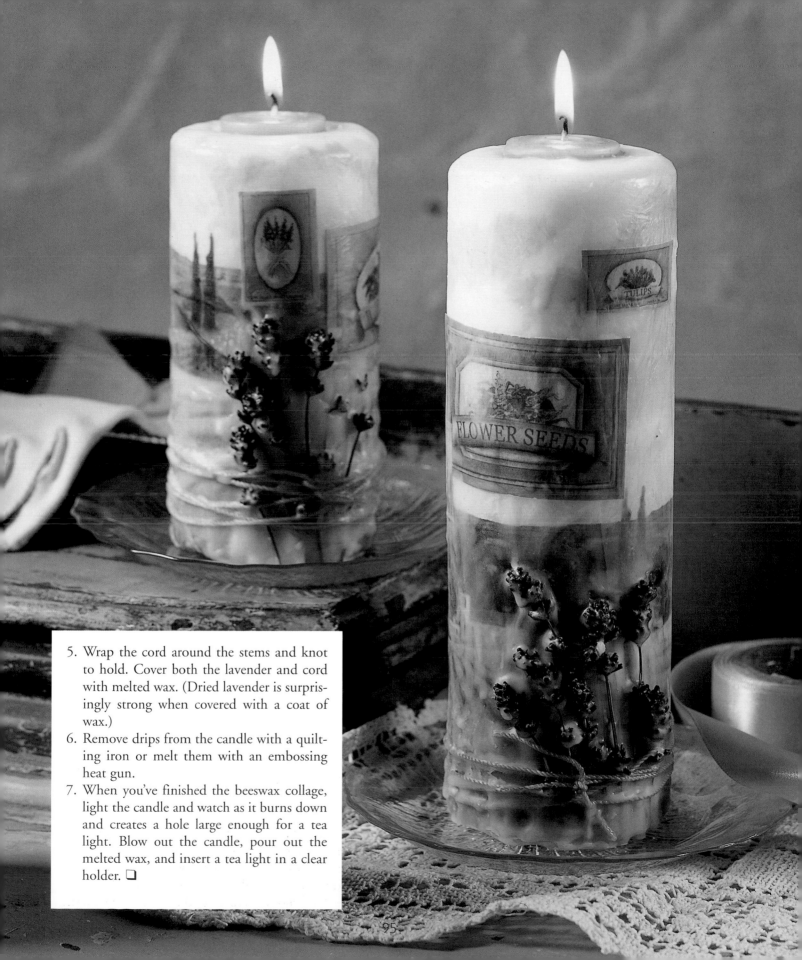

5. Wrap the cord around the stems and knot to hold. Cover both the lavender and cord with melted wax. (Dried lavender is surprisingly strong when covered with a coat of wax.)

6. Remove drips from the candle with a quilting iron or melt them with an embossing heat gun.

7. When you've finished the beeswax collage, light the candle and watch as it burns down and creates a hole large enough for a tea light. Blow out the candle, pour out the melted wax, and insert a tea light in a clear holder. ❑

Art of the Seashore

DECORATIVE TAGS

These tags were intended as decorative pieces to adorn a bathroom or cottage. The set of three can be mounted in a frame or tied to objects in the room as decorations. The seashore theme is accented with real and paper images of shells.

SUPPLIES

Base:

3 papier mache tags, 7" x 4¼"

Papers:

Handmade papers – Teal, gold

Shell motifs

Water or sea quotation stickers on clear backing

Embellishments:

Small shells (4 to 5 per tag)

Blue and green decorative fibers (20" per tag)

Bright teal jute (14" per tag)

Tools & Other Supplies:

Rubber stamp – Swirl or flourish motif

Metallic wax – Pearl blue

Basic Supplies for Beeswax Collage (See the list at the beginning of this chapter.)

Collage supplies

INSTRUCTIONS

1. Place the clear quotation sticker on the tag near the top. TIP: As you create your collage, don't cover the words.
2. Tear the handmade paper into 1" x 6" strips.
3. Working one tag at a time, brush a coat of beeswax on the tag and attach the paper strips, brushing wax over them to hold. Bring the ends of the paper strips around the edges of the tag to the back and adhere with melted beeswax.
4. Cut out the shell motifs and add to the collage with beeswax.
5. Cut 10" of the blue and green decorative fibers. Set aside the rest. Wrap the fibers around the bottom of the tag. Brush with beeswax to incorporate.

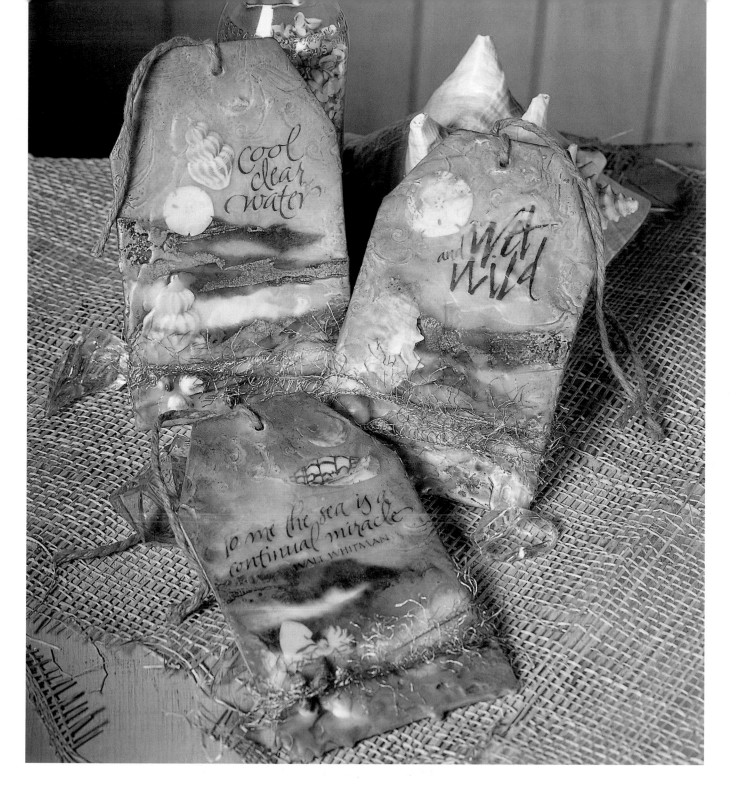

6. Add the shells in a cluster at the bottom left corner of the tag.

7. Working one area at a time, melt the beeswax around the edges of the tags with an embossing heat gun and stamp the swirl or flourish motif with the rubber stamp. Let the beeswax harden.

8. Rub metallic paste on the edges of the tag to accent the stamped texture. Let dry. Buff the surface of the tag with a soft cloth.

9. Tie the remaining piece of decorative fibers around the base of the tag.

10. If needed, clean wax from the holes of the tags with the point of a sharp pencil. Attach a length of jute through the hole at the top of each tag. ❏

Tissue Paper Collage

Tissue paper offers collage artists a brightly colored, readily available,
inexpensive paper that can be layered to create interesting effects.
The projects in this chapter show the versatility of this technique.

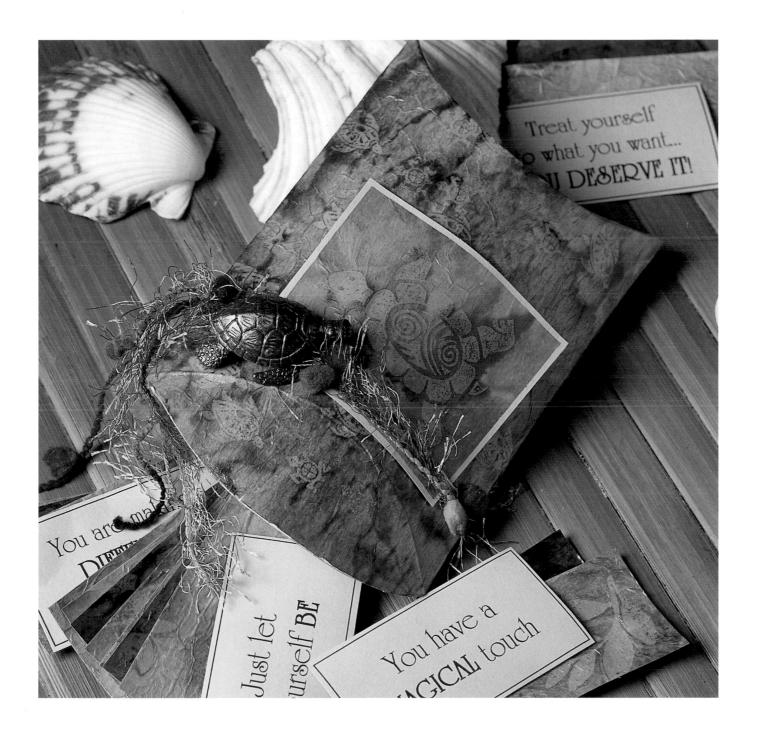

Color Transfer Tissue Paper

This technique produces a blended colored translucent paper. It is inexpensive to create and requires no paints or inks – the colors come from colored tissue paper. The process yields multi-colored tissue, and the white card stock you place under the tissue, which becomes imbued with color and pattern, can be used for card making or other paper crafting projects.

Basic Supplies

Spray bottle filled with clean water, for misting

Freezer paper *or* wax paper, to protect your surface

Several sheets of colored tissue paper (the type labeled "bleeding tissue")

White card stock

Scissors

Basic Instructions

1. Choose a work space where you can leave the paper undisturbed for the first stage of drying. Cover your work area with freezer paper or wax paper.
2. Cut the tissue paper slightly smaller than the white card stock.
3. Place the white card stock on your work surface and spray lightly with water.
4. Place a piece of colored tissue on top. Mist lightly with water.
5. Repeat with different colors of tissue, spraying with water each time until you have four to six sheets on top of each other. Leave the pile undisturbed to allow the dyes from the tissue sheets to mix and mingle.
6. When the tissue papers are just damp, peel off the individual sheets and lay flat to continue drying. The white card stock will be beautifully colored with an interesting design. **Note:** If you're disappointed with how the tissue paper looks when it's wet, don't give up! Let it dry completely before judging your success. The subtle patterns and colors aren't revealed until the paper is completely dry. ❑

Finished Tissue Paper Examples

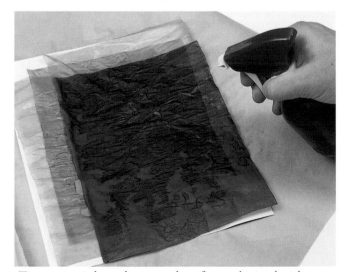

Tissue paper is layered on a work surface and misted with water.

Batik Tissue Paper

This technique is a variation of the color transfer method. It uses water-soluble dye ink applied with a rubber stamp and clear embossing powder to produce beautiful batik-like sheets of tissue paper suitable for card backgrounds and tissue collage creations.

For best results, choose three to four shades of tissue paper in the same color family (blues and greens, reds and purples, or yellow and oranges, for example), and then choose an inkpad color that coordinates with the tissue colors. The inkpad color can be from another color family – for example, with green and blue tissue, a purple inkpad was used. The ideal rubber stamp is one with large, solid motifs rather than fine details.

Basic Supplies

Spray bottle filled with clean water, for misting

Freezer paper *or* wax paper, to protect your surface

Several sheets of colored tissue paper (the type labeled "bleeding tissue")

Water-soluble dye inkpad

Rubber stamp with large, solid motifs

Clear embossing powder

Embossing heat gun

Basic Instructions

1. Choose a work space where you can leave the paper undisturbed for the first stage of drying. Cover your work area with freezer paper or wax paper.
2. Using the inkpad and the rubber stamp, randomly stamp the tissue paper.
3. Immediately sprinkle the wet ink with clear embossing powder and heat to melt and set the stamped image.
4. Working one sheet of tissue at a time, mist and stack the stamped tissue sheets to mix and blend the colors. The ink color will leach out, adding color to the tissue and leaving a faint white image of the stamp.
5. When the tissue papers are just damp, peel off the individual sheets and lay flat to continue drying. ❑

Vacation to Remember
PHOTO FRAME

A map, which can be seen through the colored tissue pieces and clear quotation stickers, is the background for the collage on this frame. It holds a favorite vacation photograph and is polymer coated for a high gloss finish. Alternately, the frame could be coated with clear gloss varnish.

SUPPLIES

Base:

Wooden frame, 10" square with a 4" square opening

Papers:

Tissue paper – Greens, yellows

Road map

Travel sayings on vellum

Daisy stickers

Tools & Other Supplies:

Acrylic paint – Very pale green

Basic supplies for Color Transfer Tissue Paper (See the beginning of this chapter.)

White inkpad

Clear embossing powder

Embossing gun

Bleach-and-water solution (1 teaspoon bleach in 3 oz. of water)

Rubber stamps – Daisy, dragonfly

Decoupage medium

Sandpaper, 300 grit

Basic supplies for polymer coating (see the list in the "General Information" chapter) *or* gloss varnish

Scissors

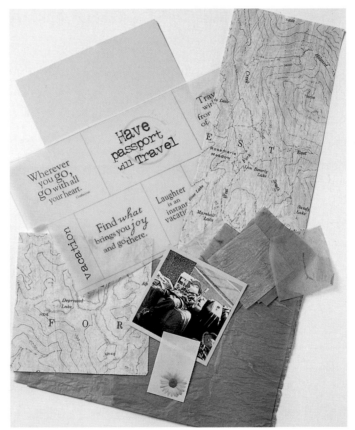

Collage supplies

INSTRUCTIONS

Prepare the Tissue Papers:

1. Cut the tissue paper into squares and rectangles in a variety of sizes.
2. Stack and mist the cut shapes with water, following the instructions for the Color Transfer Tissue Paper technique at the beginning of this chapter. Let dry.
3. Select four to five tissue pieces for stamping. Stamp the images on the tissue panels, using white ink.
4. Immediately sprinkle the stamped images with embossing powder and heat to set.
5. Paint the embossed images with the diluted bleach solution to highlight them. Let dry completely.

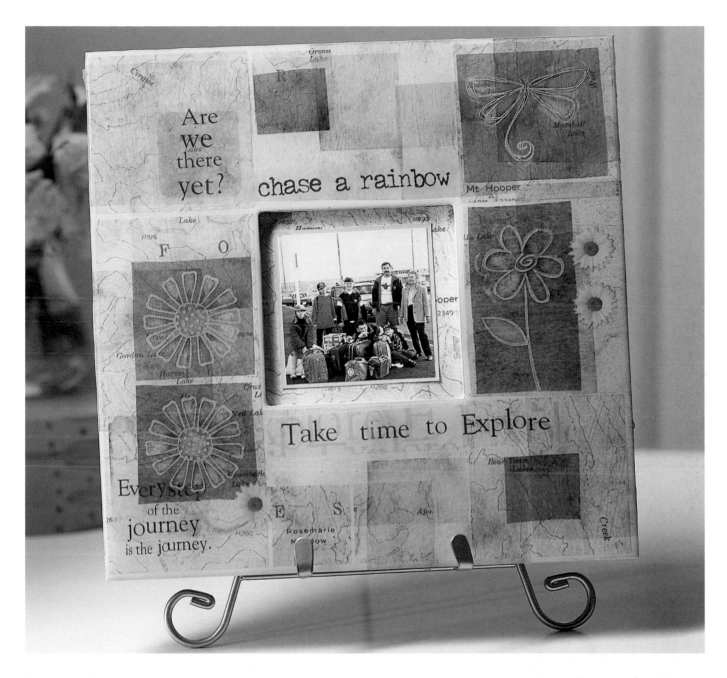

Make the Collage:

1. Basecoat the frame with pale green paint, being sure to completely cover all the edges. Let dry.
2. Decoupage the map on the front of the frame, letting the excess paper hang off the edges. Let dry.
3. Sand the edges to remove the excess paper and create a finished edge.
4. Create the collage design by layering vellum quotations, stamped color transfer tissue panels, and daisy stickers. Use decoupage medium to adhere the pieces. TIP: Don't worry about the vellum pieces wrinkling – they will smooth out as they dry. To avoid excess wrinkling use very little decoupage medium.

Finish:

1. Apply thin coats of thin-bodied white glue to the entire collage to seal. Let dry completely. **Note:** If you're finishing the collage with gloss varnish, you don't need to do this step.
2. Apply the polymer coating, following the instructions in the "General Information" chapter *or* coat the collage with gloss varnish. Let dry and cure completely. ❏

A Daisy a Day
GREETING CARDS

You can make stacks of cards quickly with tissue paper collage because you decorate the base card when you create color transfer tissue pieces. I used blue, purple, and green tissue papers. Feel free to choose your own color palette and experiment with other combinations. The two cards shown are made the same way. They differ in the placement of the elements on the background collages and in the size and choice of motif for the center panel.

SUPPLIES

Papers:

Light purple card stock, 8½" x 5¾"

White glossy card panels, 4" x 5½" and 2¼" square or smaller

Purple card stock panel, 2½" square or smaller

Tissue paper – Green, blues, purple

Embellishments:

3 silver flower charms

3 silver brads

Decorative fibers to match (20" per card)

Tools & Other Supplies:

Purple inkpad

Clear embossing powder

Rubber stamps – Daisy motifs, flowers in vases

Embossing gun

Colored felt markers

Decoupage medium

Dimensional glue dots

Glue stick

Scissors

Basic supplies for color transfer tissue paper

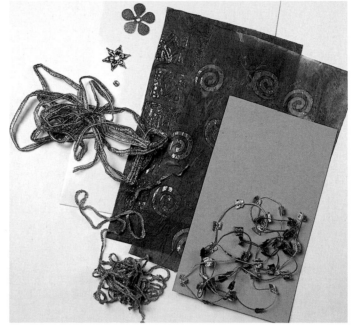

Collage supplies

INSTRUCTIONS

These instructions are for one card, but you could easily make several at a time.

1. Fold the light purple card stock in half to create a card 4¼" x 5¾".
2. Cut the tissue paper into irregular square and rectangular pieces, varying in size from 1" to 3".
3. Following the instructions for the Color Transfer Tissue Paper technique at the beginning of this chapter, stack and mist the cut tissue paper shapes on the 4" x 5½" white paper panel. Let dry.
4. Decoupage the tissue pieces to the 4" x 5½" paper panel. Let dry completely.
5. Stamp the tissue paper panel randomly with daisy motifs.
6. Stamp the square white panel with a flower motif. Sprinkle immediately with clear embossing powder. Tap off the excess powder and heat to set.

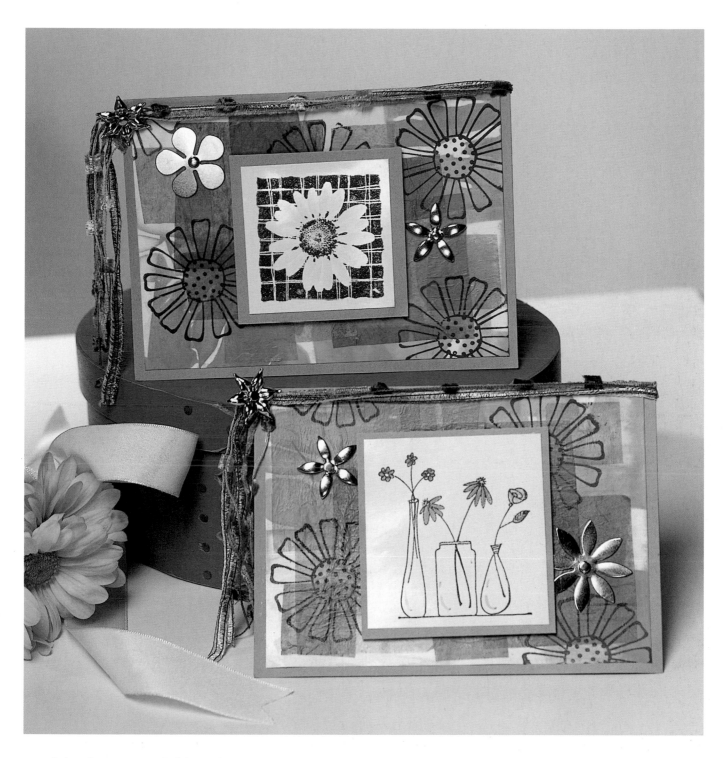

7. Color the image with felt markers.

8. Glue the stamped and embossed panel to the purple card panel.

9. Glue the stamped tissue paper panel to the card front with the glue stick.

10. Use dimensional glue dots to attach the stamped and embossed panel to the card front.

11. Tie the decorative fibers at the fold and knot to hold.

12. Embellish the card with silver flower charms, attaching them with brads. ❑

A Box of Wishes

ENCOURAGEMENT CARDS

These fun cards with words of encouragement are packaged in a pouch covered with a tissue paper collage. I used a turtle stamp on a card panel; to continue the theme, I added a toy turtle accent on the pouch. You can use any solid stamp motif as your theme and the color combinations of your choice. The cards make a welcome gift for a co-worker or friend who needs some encouraging words.

See page 108 for examples of affirmations.

SUPPLIES

Papers:

Light blue card stock, 8½" x 11"

Blank white pillow box

Tissue paper – Greens, blues, purples, cut into 8" x 10" pieces

Light blue card panel, 2¾" x 3"

Embellishments:

20" decorative fibers in matching colors

Toy turtle, 1" x 2"

Tools & Other Supplies:

Rubber stamps – Turtle, Leaf

Purple inkpad

Basic supplies for Batik Tissue Paper Technique (See the beginning of this chapter.)

Pearl decoupage medium

Paper trimmer

Hole punch

Metallic acrylic paints – Purple, green

White glue

Computer and printer

Wax paper

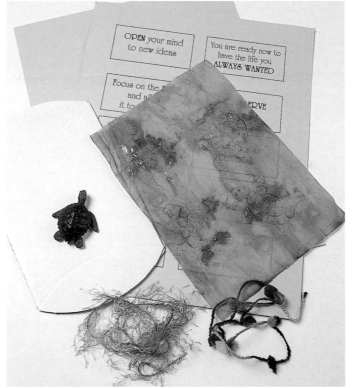

Collage supplies

INSTRUCTIONS

1. Use a computer to print encouraging affirmations on the light blue card stock. (I generated ten affirmations on the page in 1½" x 3" text boxes.)
2. Following the instructions for the Batik Tissue Paper Technique, stamp and emboss the tissue sheets, then layer and mist the stamped sheets. Let dry completely.

Continued on page 108

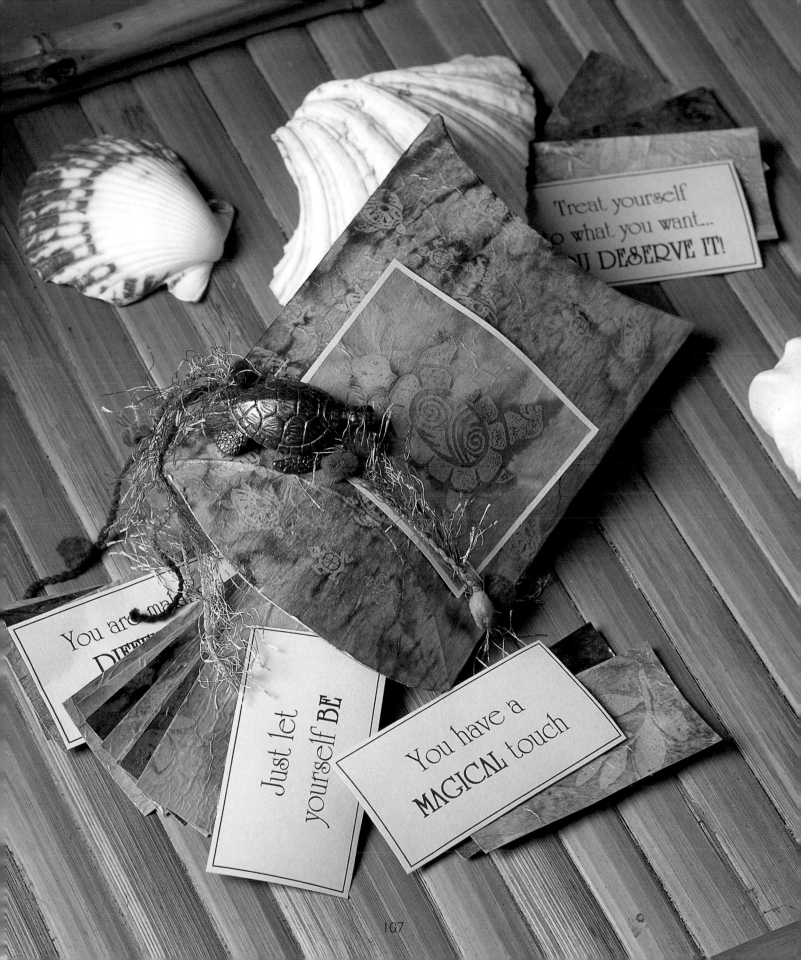

A Box of Wishes Encouragement Cards, continued

3. Using pearl decoupage medium, glue the tissue sheets to the back of the printed blue card stock. Let dry. Cut into 2" x 3½" cards.

4. Decoupage a sheet of batik tissue paper to the pillow box. TIP: Stuff the pillow box with crumpled wax paper to prevent the box from getting glued shut. Let dry.

5. Trim off the excess paper with scissors. Remove the wax paper from inside the box.

6. Cut out a panel that includes a turtle motif from the batik tissue. Glue to the small blue panel. Use a hole punch to punch four holes along one side.

7. Attach the panel to the pillow box by threading decorative fibers through the holes and around the box. Knot to hold.

8. Paint the toy plastic turtle with metallic paints. Let dry. Glue to the knot of the decorative fibers with craft glue.

9. Fill the finished box with the encouraging cards. ❑

Examples of Affirmations

You are VALUABLE to many.

Reclaim your POWER and regain your FREEDOM.

Give yourself PERMISSION to succeed.

BE YOU! THE WORLD NEEDS YOU.

Remember – this is your life. You are the BOSS!

Listen to your DREAMS.

Focus on your VISION.

Your life is coming TOGETHER now.

Just let yourself BE.

YOU HAVE A MAGICAL TOUCH.

Focus on what brings you JOY.

INSPIRATION flows from you.

Fabric Collage

Fabric collage (sometimes called "femmage") is a great way for quilters and sewers to make collages using the materials with which they are most familiar, and it's a great opportunity to use up all those scraps of decorative threads, fabric, ribbon, yarn, lace, trim, beads, and charms. Also look for adhesive-backed fabric panels and fabric strip ribbons for creating fabric collages with ease.

The projects presented in this chapter use hand stitching, but if you are comfortable using a sewing machine, feel free to add decorative topstitching to securely attach the elements.

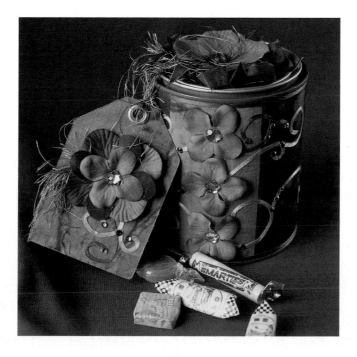

Basic Supplies

Fabric Transfers

You can purchase fabric transfers (or images printed on fabric) for fabric collages. They are popular for scrapbooking, quilting, and photo memory projects.

Cigarette Silks

Cigarette silks are antique fabric transfers that are easy to find and relatively inexpensive. At the beginning of the 20th century, tobacco companies inserted a small silk picture in cigarette packages marketed to women. The silk pictures were highly prized and collected to include in crazy quilts. Ask for them at antiques shops – you may be surprised to see a large binder full of these gems come from under the counter.

Iron-on Transfer Paper

Both color copier and inkjet papers can be used to transfer a design to fabric. The image is printed on paper with a computer printer, then ironed on the fabric. When the paper backing is peeled away, the image is revealed. **Note:** This technique requires you to print the image in reverse.

Adhesive-backed Fabric

These 12" square fabric panels are easy to cut and layer, and the adhesive adheres to a variety of surfaces, including paper, tin, and wood. Look for these panels at quilting and scrapbooking stores.

Option: If you are unable to find these panels, substitute fabric backed with a fusible web. Trace your design and cut out the shapes before removing the backing paper. Secure the pieces in place with an iron on a medium-high, no steam setting.

Iron-on Ribbons & Threads

Iron-on ribbons and threads offer a simple way to outline a motif or embellish your collage. Thin (1/8") ribbons and braided threads come in a variety of colors, including metallics. They adhere to fabric and paper surfaces when heated with an iron. I use a tiny quilting iron for best results.

Here's how:
1. Transfer a pattern with fabric transfer paper or draw guidelines with an air-erase pen on your surface.
2. Using the iron set at medium heat, guide the ribbon along the pattern lines and tack in place as you go with the iron.
3. Trim the end of the ribbon or thread with sharp scissors. Place a non-stick pressing cloth over the design and iron again to ensure a secure hold.

Basic Techniques for Fabric Collage

Attaching Fabric to a Paper Base

To give your fabric collage stability for postcard, greeting card, and artist trading card projects, the fabric is fused to a paper base.

Here's how:
1. Cut a piece of fusible web slightly smaller than the fabric piece.
2. Sandwich the web between the fabric and the paper.
3. Fuse with a hot iron set at medium-high, no steam.

Antiquing & Coloring Fabric

Small dye baths (1 to 2 cups) are sufficient for dyeing small items such as fabric pieces, lace, ribbon, crocheted doilies, and fabric embellishments. Natural fibers – cotton, linen, silk, and wool – work best, although some fabric blends also can be dyed. Various types of fabric absorb dye differently, creating different shades. Experiment and test the fabrics to see how they react to dye.

Antiquing & Coloring Recipes

Tea and coffee dye baths gently tint the fabric for an antique look reminiscent of age. The powdered fruit drink dye bath is an alternative to purchased color dyes. The procedure is the same for all three dye bath recipes.

Tea Dye Bath

Different tea blends offer different colors. For example, berry-based herb tea is pinkish, while orange pekoe tea is an orange sepia hue.

Ingredients
4 two-cup tea bags
1 heaping tablespoon salt
2 cups boiling water

Coffee Dye Bath

Coffee imparts soft beige to warm brown tint to fabric.

Ingredients
4 tablespoons instant coffee
1 heaping tablespoon salt
1 cup boiling water

Basic Dye Bath Instructions

1. Soak the fabric pieces and trims in room temperature water for 10 minutes.
2. Prepare the dye bath by mixing together the recipe ingredients. Stir to completely dissolve coffee and fruit drink crystals. Steep tea bags for 10 minutes and remove.
3. Squeeze out the excess water from the soaked fabric pieces and place in the dye bath. Soak until the desired shade is obtained. For strong hues, let the fabric sit in the dye bath until it cools to room temperature. **Note:** The fabric color is always darker when wet. It will be lighter in color when it dries.
4. Fill a large bowl with room temperature water. Add the fabric pieces and gently swish to rinse. Drain and repeat the process with fresh water until the water remains clear. *Note:* It's especially important to completely rinse pieces from the tea dye bath. Tannic acid, a component of tea, can be harmful to the longevity of the collage.
5. Lay the fabric pieces on an old towel. Dry flat. ❑

Powdered Instant Fruit Drink Dye Bath

The darker colors of instant fruit drinks work best. Lighter colors are excellent for color mixing, which gives flexibility and a greater array of colors. For example, place the fabric item in a red dye bath, then dip in a green dye bath to create a muted, dusty rose color. Experiment! Dye the fabric piece with the lightest color first.

Basic Ingredients
For each dye bath
1 pkg. (1.4 oz.) unsweetened instant powdered fruit drink (cherry for red, grape for purple, lime for green, etc.)
1 cup boiling water
1 oz. white vinegar

Wish You Were Here
VACATION POSTCARDS

In the late 19th century, some postcards were made from embroidered silk and mounted on paper bases. Fabric postcards are again a popular collage project and are exchanged between quilting artists like ATC cards.

Fabric postcards can be mailed if they are the standard postcard size (6" x 4") and are less than ¼" thick. Use a heavyweight paper as the base, write the word "postcard" on the back, and draw a line to divide the message space (on the left) from the address space (on the right). You can request special handling by writing "hand cancel" on the back of the postcard. Be sure no pieces stick out that could get caught in postal service machines. Many designers use a sewing machine to securely flatten and attach the collage elements. Mail hand stitched postcards in an envelope.

SUPPLIES

Base:
Cream cardstock, 6" x 4"

Collage Materials:
Thin cotton batting, 5¾" x 3¾"
Lightweight green fabric, 5¾" x 3¾"
Purple embroidery floss, divided into three strands
Butterfly lace motif
Ribbon with lettering (to match your theme)
Fabric transfer image, 2" x 3½"
Fusible web, 5¾" x 3¾"

Embellishments:
Velvet leaf
Cream crocheted motifs – Flower, butterfly
Buttons – Green, purple, mother of pearl (5 per card)

Tools & Other Supplies:

Scissors	Embroidery needle
Pins	Air-erase marker and ruler
Iron	Black permanent marker

Collage supplies

INSTRUCTIONS

1. Pin the cotton batting and fabric together. Pull threads from the fabric to slightly fringe the edges.
2. With the air-erase marker, drawn straight lines 1" apart diagonally across the fabric.
3. Thread the needle with embroidery thread and sew a

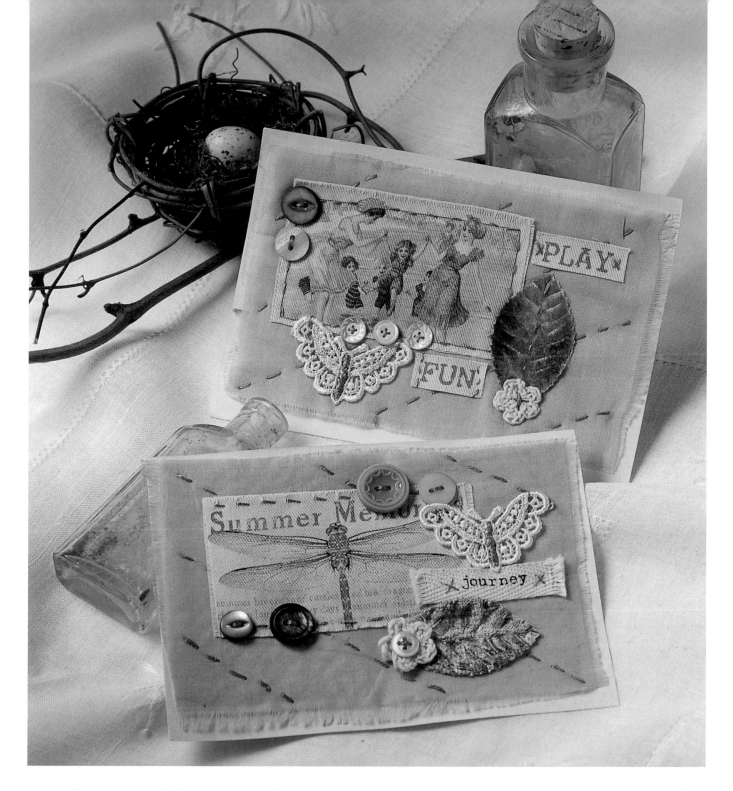

simple running stitch down each marked line. Knot to secure the end.

4. Using embroidery thread and a needle, attach the fabric transfer panel, ribbon pieces, velvet leaf, crocheted motifs, and the buttons. See the project photo for placement ideas.

5. Use a permanent marker to write "Postcard" and a dividing line on the card stock.

6. Sandwich the fusible web between the card and the fabric collage. Iron to fuse the pieces together, following the fusible web manufacturer's instructions. ❑

Sisters

FRAMED COLLAGE

Vintage photographs were photocopied onto iron-on transfer paper and fused to
a lace hankie with a hot iron. Colored lace and crocheted motifs, buttons, ribbons,
and simple stitches were added to create this handstitched fabric collage.

SUPPLIES

Base:

White shadow box frame with
 glass, 10" square

Thin cotton batting, 10" square

Collage Materials:

Old embroidered and lace-edged
 handkerchiefs

Lace pieces (some tea-stained)

Colored crocheted and lace motifs

Iron-on transfer paper

Vintage photographs

Embellishments:

Green satin ribbon, ⅛" wide and
 ¼" wide

Mother of pearl buttons

Seed beads – Pearl green, pink

Tools & Other Supplies:

Cream thread

Pink embroidery floss, divided into
 two strands

Needle with a fine eye

Pins

Fabric glue

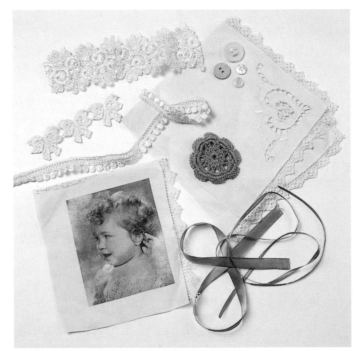

Collage supplies

INSTRUCTIONS

1. Following the instructions on the iron-on transfer package, transfer the photographs to the vintage handkerchiefs.
2. Following the instructions at the beginning of this chapter for Antiquing & Coloring Fabric, dye the lace and crocheted pieces.
3. Trim the hankies with the images. Arrange them and other lace-edged hankie panels on the cotton batting. Pin in place.
4. Run satin ribbons through some of the lace pieces.
5. Gather all the collage elements and start arranging the collage. When you are happy with the design, pin the pieces in place.
6. With a needle and thread, use simple stitches to attach all the collage elements to the hankies and batting.

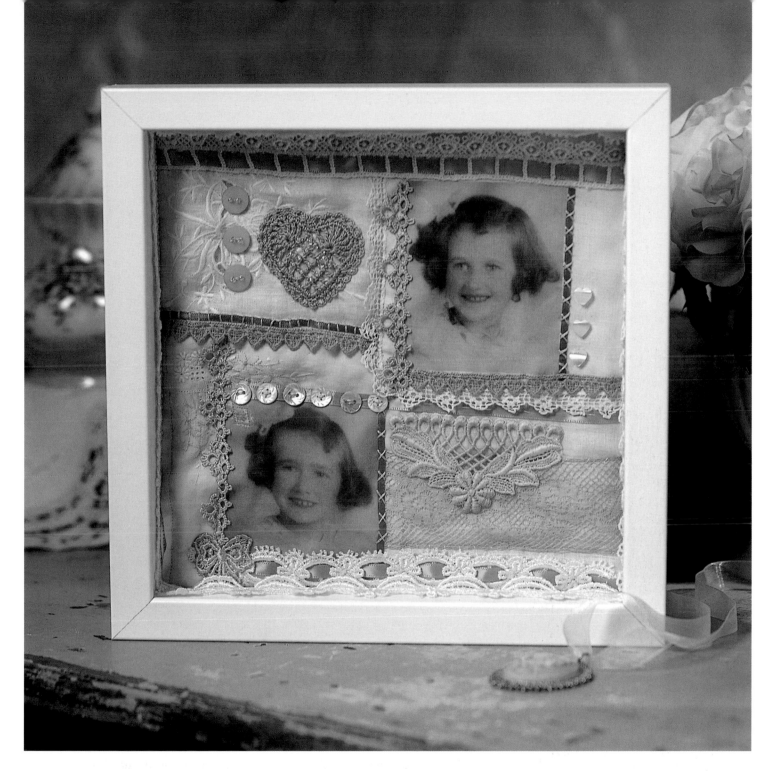

7. Thread the needle with pink embroidery floss. Add decorative stitches and the buttons.

8. Stitch seed beads on fabric pieces to accent and add sparkle.

9. Using fabric glue, decorate the inside edges of the frame with lace. Let dry completely.

10. Mount the glass, the collage, and a backing board in the frame. ❑

Pretty Paisley
DECORATIVE BOX

Adhesive-backed fabric is cut into shapes and layered to create a paisley design on a box top. The design is accented with fabric paint and beads to make a gorgeous, useful container for jewelry or other small objects.

SUPPLIES

Base:

Hinged wooden box, 5½" x 9½" x 1¾" deep

Adhesive-backed Fabrics:

Batiks in 12" square sheets – Turquoise, dark purple, olive green, patterned olive green, light purple/blue

Embellishments:

Purple E-beads

Micro bead without holes – Light teal, purple

5 round silver beads, ½"

2 yds. teal iron-on ribbon, ⅛" wide

Dimensional fabric paints – Silver, dark purple

Tools & Other Supplies:

Acrylic paint – Teal

5 brass finishing nails, ¾"

Scissors

Air-erase marker and ruler

Water-erase transfer paper

Tracing paper and pencil

Wax paper

Iron

Craft glue

Collage supplies

INSTRUCTIONS

Paint:

1. Remove all the hardware from the box and set aside.
2. Paint the inside of the box with teal paint. Let dry.

Cover with Fabric:

Use the adhesive-backed turquoise fabric.

1. Measure the top of the box and cut a fabric panel. Remove the backing paper and place on the box top.
2. Measure and cut one strip of fabric to fit around the sides of the lid. Remove the backing paper and position.

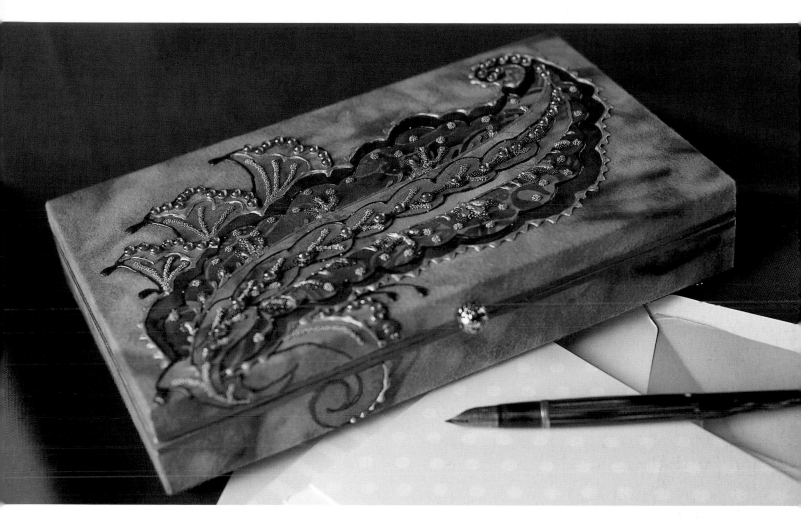

3. Cut a second strip of fabric for the sides of the box base that is ½" wider than the width of the sides. Remove the backing paper and position the strip, overlapping the extra ½" on the bottom of the box.
4. Re-attach the hinges.

Make the Collage:
1. Trace the paisley pattern on a piece of paper. Use water-erase transfer paper to transfer the design elements to the fabric pieces.
2. Cut out all the motifs.
3. Working one piece at a time, remove the backing paper and assemble the paisley design on a piece of wax paper using the pattern as a guide. When complete, remove from the wax paper and place onto the box top. (A small portion of the pattern will overlap the front of the box.)
4. Burnish the paisley design to adhere securely. Use an art knife to cut the fabric where it overlaps the box opening.
5. Attach the iron-on ribbon to the box edges where the top and bottom parts of the box meet.
6. Using the project photo as a guide, apply dimensional paint to the paisley outlines. Sprinkle the paint with one color of micro beads while the paint is still wet, then tap off the excess beads on a piece of paper to collect and reuse. Allow to dry completely. Apply the second color of micro beads, following the same instructions.
7. Accent the design with dimensional paint.
8. Use drops of silver paint to adhere the E beads. Let dry completely.
9. Use finishing nails to attach four silver beads to the bottom four corners (for feet) and one to the front of the box (as a handle). TIP: Add a small drop of craft glue under each bead for extra hold. ❑

Patterns
Enlarge @200% for actual size.

1. Olive green

2. Light purple/blue

Pattern Placement

3. Olive green patterned

4. Dark purple

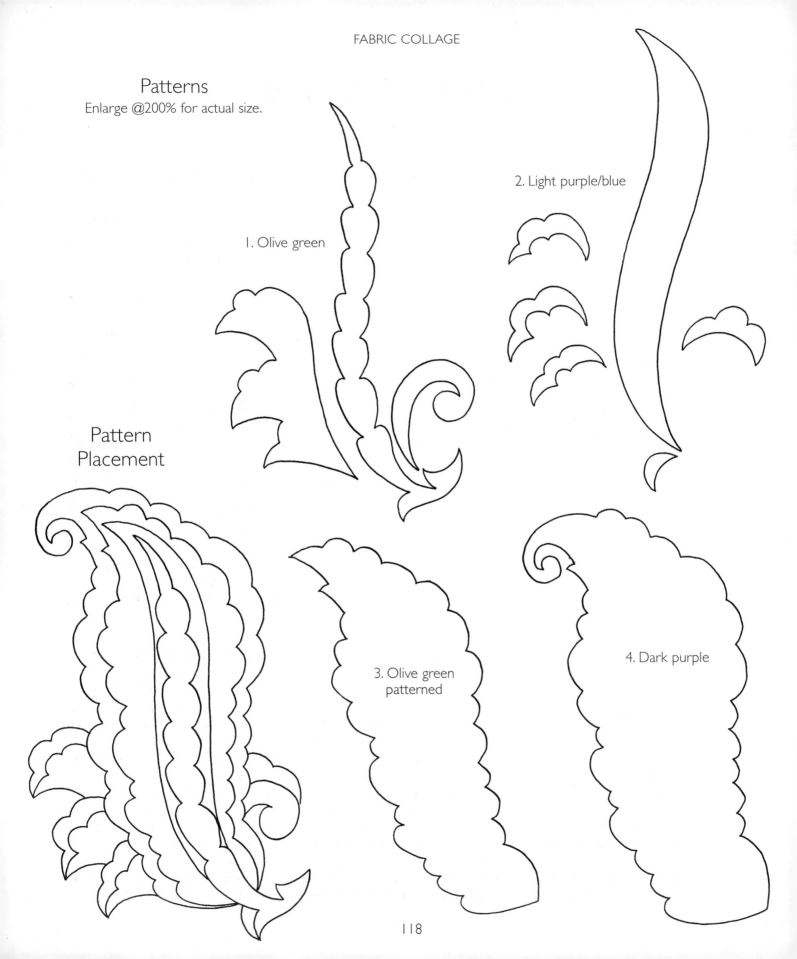

Flowery Collage
GIFT TIN

Covering a tin with adhesive-backed fabric is easy and quick. Fill it with homemade goodies or a small gift.

SUPPLIES

Base:
Round tin with lid, 5" tall x 4" diameter

Adhesive-backed Fabrics:
Batiks in 12" square sheets – Dark red/purple print, olive green

Embellishments:
Rhinestones – Green, purple, pink
Purple silk flowers, 2½", 1½"
Iron-on ribbons – Purple, lime green
Paper tag, 3" x 4½"
Matching fabric strip ribbon (for bow)
Green decorative fibers

Tools & Other Supplies:
Silver eyelet, ½"
Craft glue
Scissors
Air-erase marker
Measuring tape
Towel

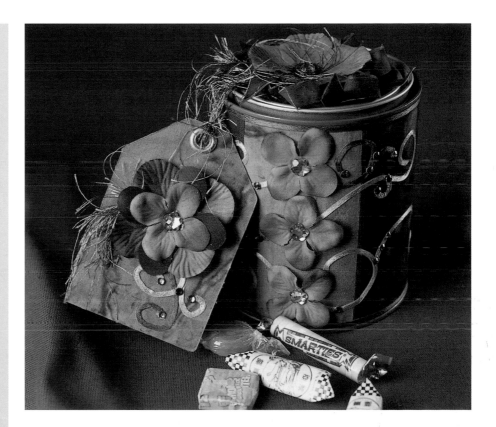

INSTRUCTIONS

1. Measure, cut, and apply the dark red/purple fabric to the tin. (The 12" length will leave a 2" gap.)
2. Measure, cut, and apply a 3" strip of green fabric to cover the gap.
3. Measure, cut, and apply a circle of green fabric to cover the top of the lid.
4. Cut and apply a piece of green fabric to cover the paper tag.
5. Cut pieces of iron-on purple ribbon to fit along the sides of the green panel and top and bottom rims of the tin. Apply.
6. With the air-erase marker, draw the swirls on the tin and the tag. Iron green and purple ribbons on the swirl guidelines, using the photo as a guide for color placement.
7. Lay the tin on its side and support it with a towel to prevent it from rolling. Glue three silk flowers to the green fabric panel. Add green rhinestone centers. Let dry.
8. Add rhinestones to the ribbon swirls, adhering them with drops of glue.
9. Make a multi-loop bow with the matching fabric strip ribbon. Glue to the top of the lid. Glue a silk flowers in the center. Glue a green rhinestone in the center of the silk flower.
10. Glue a silk flower with a green rhinestone center to the tag.
11. Make a double loop with the decorative fibers and glue it under the bow. Make another loop and glue under the silk flower on the tag.
12. Insert the silver eyelet in the top of the tag. Attach the tag to the tin with decorative fibers. ❏

Casting Collage

The collage projects in this chapter are layered and permanently encased in a clear resin casting. When you incorporate a collage in a casting, you work in reverse order and upside down, placing items for the top of the collage first. Both flat items like papers and photographs and three-dimensional materials like keys and charms can be used to create cast collages. The finished casting can be used as a paperweight or can be drilled to add a pen holder or recipe clip.

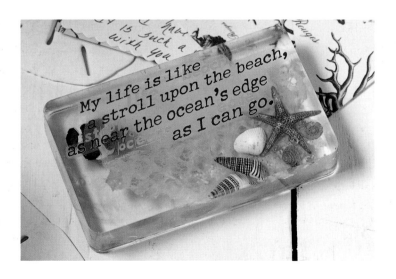

Basic Supplies for Casting Collage

Epoxy Casting Resin

Epoxy casting resin works great for casting small objects. It has an easy mixing ratio (1:1 – no catalyst calculations), good bubble release, and low odor because it's solvent-free. When the two parts (a resin and a hardener are mixed together), a chemical reaction causes heat that cures and hardens the resin. You can make clear castings, or – by adding objects, colors, or powders – an infinite array of designs can be created. The disadvantages are that you're limited to a maximum clear pour of 6-ounces and that the casting is much softer than polyester resin so it can't be sanded and buffed to a high-gloss finish. When you sand and polish an epoxy resin casting, you achieve a matte finish.

Release Agent

Use a release agent recommended for epoxy resin casting. It's generally sold beside the casting resin in crafts and hardware stores.

Molds

Polypropylene and polyethylene molds that are manufactured for resin are best; latex rubber molds and silicone molds also work well. The molds are smooth and shiny so the cast pieces come out clean and polished, with no buffing required. With proper care and use of a mold release, molds can be used for multiple castings.

Miscellaneous Supplies

Mixing cups (Use disposable graduated plastic cups.)

Wooden stir stick

Disposable glue brush, for brushing the objects with liquid casting resin before placing to avoid air bubbles

Latex gloves, to protect your hands

Freezer paper *or* wax paper, to protect your work surface

Permanent marker, for marking the measuring cups

Paper towels, for wiping

Sandpaper, 150-grit

Hair dryer, for removing bubbles

Car wax *or* carnauba wax, for polishing

Objects to Embed

Items that can be embedded in resin include coins, shells, photos, metal objects such as charms and keys, buttons, and dried flowers. **Never** use a fresh flower or any object with moisture in it. Cut motifs from paper, photographs, and stickers also can be placed in resin. Many non-coated papers become transparent when added to resin, a nice effect that allows you to layer images. If you don't want a transparent image, seal non-coated papers with a laminating film or two coats of white glue. Let the seal coats dry completely before adding the paper to the resin in the mold cavity.

Basic Instructions for Casting Collage

Follow these instructions for collage casting or anytime you want to imbed objects in a cast piece. Remember that when you create a collage in a mold you are working upside down and in reverse order. Place the items you wish to appear in the front of your collage in the first layer of resin, working your way to the back (bottom) layer. **Always** place the items in the resin upside down (or on the reverse side). The collage is assembled in layers, and each layer requires a fresh mixture of casting resin.

Preparation

1. **Prepare your work area.** Cover your work area with freezer paper or wax paper to protect the work surface.
2. **Condition the mold.** Spray the mold with mold release. Wipe away excess moisture from the entire mold cavity, using a clean paper towel. Set aside to dry.
3. **Organize the collage elements.** Organize all the collage elements in the order that they will be placed in the layers.

Mixing

4. **Label and measure.** With the marker, label the measuring cups #1 and #2. Estimate the amount of casting resin you need for the number of pieces you wish to make. You need a minimum of two ounces for proper mixing. Place equal amounts of hardener and resin in cup #1. **Do not guess!** The measurements need to be exact or the castings will not harden properly. Mix only what you need – you cannot save the mixed resin for a later pouring.
5. **Mix in cup #1.** Mix the hardener and the resin together well for a full two minutes, using the stir stick. Scrape the sides and the stir stick often to ensure complete mixing.
6. **Pour into cup #2.** Pour the mixed resin in cup #1 into cup #2. Scrape the resin off the inside of cup #1 and the stir stick. Set aside cup #1. Mix the resin in cup #2 for one minute.

Pouring & Layering

7. **Pour into the mold.** When the mixing is complete, pour a ¼" layer of clear resin in bottom of a prepared mold. Don't worry if you drip resin on the mold; it will come off easily after hardening.
8. **Remove any bubbles.** If, after 10 minutes, there are bubbles on the surface, remove them by passing a hot hair dryer gently over the mold.

9. **Start the collage.** Place the first layer of collage elements into the still-liquid resin. Bubbles can form in the casting from air that is trapped under the items in your collage. To prevent bubbles in the casting, brush each object to coat it with resin before adding it to the mold. Let cure until the resin is firm and gel-like, about four hours.
10. **Create the second layer.** Mix more resin for the second layer, following the previous instructions for mixing. Pour a ¼" layer of resin in the mold, remove any air bubbles, and add the second layer of collage elements. As before, brush each object to coat it with resin before adding it to the mold. Let cure until the resin is firm and gel-like.
11. **Complete the collage.** Continue to layer and fill the mold, letting each layer cure to a firm gel-like consistency (again, about four hours) before adding the next layer.

Curing

12. **Let cure.** If, after 10 minutes, there are bubbles on the surface, remove them by passing a hot hair dryer gently over the mold. Leave the resin to cure and harden. Let the collage cure one more day before removing it from the mold.
13. **Release the casting from the mold.** When the resin has cured completely, gently press the back of the mold with your thumbs to turn out the cured pieces.
14. **Sand the back of the casting.** Remove the sharp edges from the cast piece by stroking with a piece of 150-grit sandpaper. Hold the casting at a 45-degree angle to the surface of the sandpaper to prevent marring the top of the casting.
15. **Polish.** Rub the cast piece with car wax or carnauba wax to help eliminate the sanded white edge and to protect the cast piece from scratches. ❏

African Safari
PAPERWEIGHT

This casting's technique is a little different. After the casting was made and removed from the mold, more elements were added on the top, then coated with freshly mixed epoxy casting resin. It gives the look of a hand blown piece of glass.

SUPPLIES

Basic Supplies for Casting Collage – See the beginning of this chapter. I used a resin mold, 3" square.

Collage Layers in the Mold

First layer – African postage stamp, torn piece of vellum with journey quotation

Second layer – Gold zebra novelty button, torn piece of leopard print tissue paper

Third layer – decorative paper with map design

Collage Elements Added on Top of the Casting

Torn strips of leopard print tissue paper

Round "Travel" sticker, 1"

Clear round resin dome, 1"

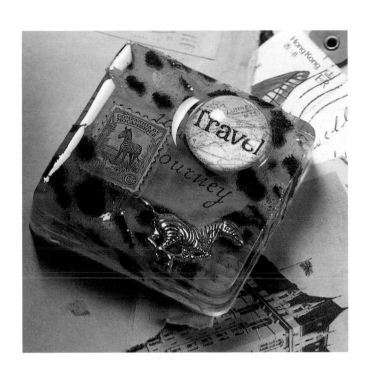

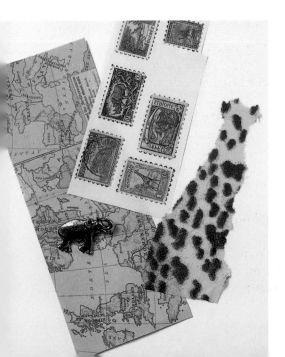

INSTRUCTIONS

To make this casting, follow the Basic Instructions for Casting Collage at the beginning of this chapter, then add the top layer following the instructions below.

Top Layer:

1. With a glue stick, glue strips of leopard print tissue diagonally across the top of the casting and around the sides.
2. Using the photo as a guide, position the round "Travel" sticker on the casting over the paper strips.
3. Prepare 2 oz. of casting resin, following the instructions for mixing. Place the casting on your protected work surface on a disposable paper cup.
4. Pour the mixed resin over the top of the casting. When the resin has stopped dripping, place the clear dome on top of the round "Travel" sticker.
5. Let cure completely. Trim away the excess paper with scissors and sand off any bottom drips. ❑

Inspired by Nature

PAPERWEIGHT

Instead of trying to capture a real beetle, I found wonderful toy bugs that I painted with metallic paints to give them a colorful and realistic gleam. Carefully consider where to place the paper images when planning the casting. I made sure the skeleton leaf was placed against both a light and a dark background to showcase all its intricate details.

SUPPLIES

Basic Supplies for Casting Collage
 – See the beginning of this chapter. I used a rectangular resin mold,
3" x 4¾".

Collage Layers

First layer (foreground) – Copper skeleton leaf and plastic toy beetle, 1" x 2", painted with metallic paints.

Second layer (middle ground) – Pressed leaf, 3 seeds.

Third layer (background) – Paper image of nest and letters.

To make this casting, follow the Basic Instructions for Casting Collage at the beginning of this chapter.

Good Fortune
PAPERWEIGHT

Chinese coins and paper money images are encased with a good luck fortune in this casting. According to Feng Shui principles, displaying symbols of abundance helps attract wealth.

SUPPLIES

Basic Supplies for Casting Collage – See the beginning of this chapter. I used a resin mold, 3" square.

Collage Layers

First layer (foreground) – Fortune printed on a slip of paper, 3 Asian coins.

Second layer (middle ground) – Translucent money stickers, a torn piece of thin washi paper printed with Chinese characters.

Third layer (background) – Decorative paper with Asian images and characters.

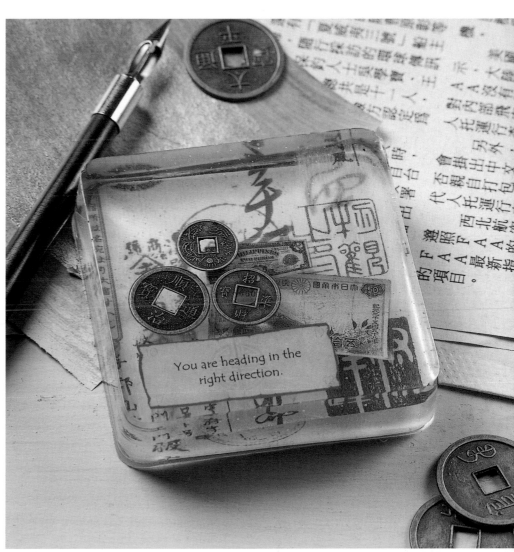

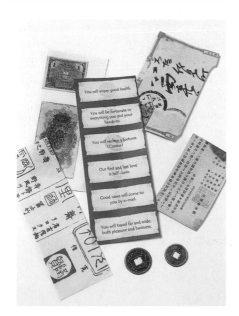

To make this casting, follow the Basic Instructions for Casting Collage at the beginning of this chapter.

Seaside Sentiments

PAPERWEIGHT

Thin washi papers, shells collected at the beach, a dried starfish, a sea-inspired quotation, and a plastic toy fish are embedded in this marine-themed paperweight.

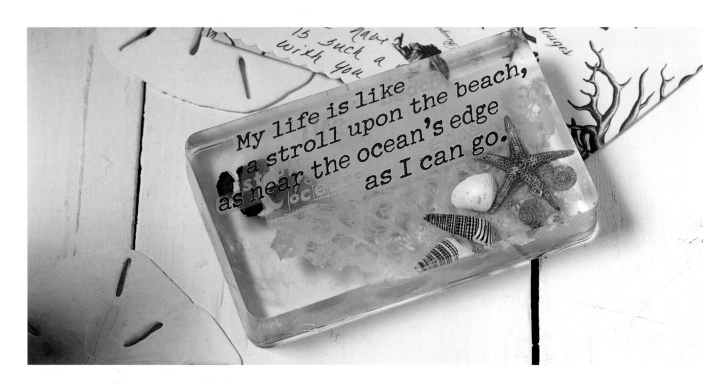

SUPPLIES

Basic Supplies for Casting Collage – See the beginning of this chapter. I used a rectangular resin mold, 3" x 4¾".

Collage Layers

First layer (foreground) – Sea quotation on clear transparency, shells, dried starfish.

Second layer (middle ground) – Torn piece of thin washi paper painted a light sand color; toy fish, 1½" x 1".

Third layer (background) – Torn piece of thin blue mulberry paper.

To make this casting, follow the Basic Instructions for Casting Collage at the beginning of this chapter.

Metric Conversion Chart

Inches to Millimeters and Centimeters

Inches	MM	CM	Inches	MM	CM
1/8	3	.3	2	51	5.1
1/4	6	.6	3	76	7.6
3/8	10	1.0	4	102	10.2
1/2	13	1.3	5	127	12.7
5/8	16	1.6	6	152	15.2
3/4	19	1.9	7	178	17.8
7/8	22	2.2	8	203	20.3
1	25	2.5	9	229	22.9
1-1/4	32	3.2	10	254	25.4
1-1/2	38	3.8	11	279	27.9
1-3/4	44	4.4	12	305	30.5

Yards to Meters

Yards	Meters	Yards	Meters
1/8	.11	3	2.74
1/4	.23	4	3.66
3/8	.34	5	4.57
1/2	.46	6	5.49
5/8	.57	7	6.40
3/4	.69	8	7.32
7/8	.80	9	8.23
1	.91	10	9.14
2	1.83		

Index

A
A Box of Wishes Encouragement Cards 106
A Daisy a Day Greeting Cards 104
A Dinner to Remember Photo Placemats 82
A Fitting Gift Puzzle Tags 40
A Fitting Greeting Puzzle Cards 38
Adhesives 13
African Safari Paperweight 123
Altered art 10
Altered Art Collage 65
Antiquing gel 34, 44
Antiquing recipes 111
Appropriation 10
Art knife 12, 14, 34, 36, 38, 40, 56, 58, 66, 90
Art of the Seashore Decorative Tags 96
Artist trading cards 10
Artistic Assemblage Display Art 74
Artistic Greetings Decollage Cards 90
Assemblage 10
Awl 38, 40, 90

B
Basic Collage Projects 32
Basic Supplies 12
Batting 112, 114
Beads 34, 61, 62, 63, 64, 70, 90, 114, 116
Beeswax collage 10, 86, 87, 88, 90, 92, 94, 96
Beetle 124
Berries 88
Bezel(s) 61, 62, 63, 64
Bleach 102
Bold Botanical Serving Tray 56
Bone folder 12, 14, 26, 36, 44

Book 66
Book pages 34, 56
Bottles 76
Box 54, 58, 106, 116
Brads 38, 40, 42, 74, 76, 104
Bricolage 10
Brush 38, 40, 42, 44, 50, 74, 76, 121
Buckle 54
Bullion 70
Buttons 46, 54, 112, 114, 123

C
Candles 94
Canvas
board 80
stretched 80
Card stock 36, 38, 40, 42, 46, 48, 90, 100, 104, 106, 112
Card(s) 34, 36, 38, 90, 104, 106
Cast collage 11
Casting Collage 120
Chalk 34, 66
Charm(s) 34, 42, 46, 61, 62, 63, 64, 70, 88, 90, 92, 104
Cigarette silks 110
Clamps 50, 66
Clip 36
Coaster(s) 48, 52
Coffee 22, 56, 111
Coins, Asian 125
Collage
altered art 65
basic projects 32
beeswax 86
casting 120
casting, basic supplies 121
casting, instructions 122
design 17
fabric 109

fabric, basic techniques 110
framed 44, 114
glossary 10
history 9
jewelry 60
photo 78
protecting 29
tissue paper 98
Coloring recipes 111
Computer 106
Contact paper transparencies, *see transparencies*
Cord 64, 92, 94
Craft stick 61
Cups 121
Cutting mat 12, 14, 34, 36, 38, 40, 56, 58, 90

D
Decal transfer film 26
Decollage 11
Decoupage 11
Decoupage medium 12, 13, 24, 38, 40, 46, 50, 54, 56, 58, 70, 74, 76, 82, 83, 84, 85, 102, 104, 106
Decoupaged Surface 20
Design elements 18
Designing Your Collage 18
Distressed Metal 21
Domino 36
Dye bath, fruit drink 111

E
Embellishment(s) 15
Embossing heat gun 101, 102, 104
Embossing powder 101, 102, 104
Embroidery floss 112, 114
Envelope 34, 36

Ephemera 14
Eyelets 34, 119

F
Fabric 112
adhesive-backed 110
antiquing 111
collage 109
coloring 111
transfer 112
Femmage 11
Fibers 38, 40, 58, 76, 96, 104, 106, 119
File 50
File in Style Mail & Letter File 49
Flower(s) 38, 40, 42, 70, 76, 119
Flowery Collage Gift Tin 119
Foam core 80
Folder, *see Bone folder*
For a New Mommy Copper Pin 62
Fortune 125
Frame 44, 102, 114
French Angel Pendant Necklace 63
Friends Puzzle Framed Collage 44
Fusible web 112

G
Gel pen 36, 38
General Information 17
Gesso 38, 40, 44, 56, 70, 74, 82, 83, 84, 85
coating 20
Gift of a Garden Greeting Cards 34
Glitter 66
Glossary, collage 10
Gloves, latex 121
Glue
craft 12, 13, 24, 34, 36, 46, 50, 54, 58, 66, 70, 76, 90, 116, 119

Continued on next page

dots 12, 13, 36, 44, 46, 104
fabric 114
jewelry 61
stick 12, 13, 24, 34, 36, 38, 40, 42, 66, 104
thin-bodied white 13, 52, 56, 61, 66, 80, 106
Gluing Techniques 24
Good Fortune Paperweight 125

H
Hair dryer 121
Hammer 74
Handkerchiefs 114
Headpins 61, 62, 63, 64
History of Collage 9
Hole punch 40, 106
Home Sweet Home Framed Mirror 46
Home Sweet Home Paperweight 48

I
Image collections 14
Images 26, 61, 62, 74, 82, 85, 92, 124
Ink 34, 70
Inkpad(s) 38, 40, 42, 44, 50, 74, 76, 88, 102, 104, 106
Inspired by Nature Paperweight 124
Introduction 8
Iron 112, 116

J
Joy Without End Wall Sign 88
Jump rings 61, 62, 63
Jute 96

K
Key 46

L
Label holder 50, 92
Labels 94
Lace 112, 114
Lanyard 58
Lavender Fields Candles 94
Leaf *or leaves* 52, 70, 88, 112, 124
Letters <I>or alphabet<P> 48, 50, 58, 74, 88
Live-Love-Laugh Wooden Purse 58

M
Magnet(s) 54
Mannequin 74
Map 85, 102
Marker(s) 104
air-erase 112, 116, 119
permanent 112, 121
Marking the Spot Peat Pots 92
Measuring tape 119
Message on a Bottle Altered Bottles 76
Metal corners 42
Metal 21
Miniature Collage Jewelry 60
Mirror(s) 46, 58
Mixed media 11

Mold(s) 48, 121, 123, 124, 125, 126
Money 125
Montage 11
Motif(s) 80, 96, 112
cutting 22

N
Nail(s) 74, 116
Napkins 88
Nature collage 11
Nature Tiles Coasters 52
Necklace 63, 64
Needle 114
embroidery 112

O
Organized Sewing Tin Sewing Box 54

P
Paint 38, 40, 44, 50, 52, 58, 66, 70, 74, 76, 80, 82, 83, 84, 85, 102, 106, 116, 124
basecoating 20
fabric 116
Palette 74
Paper(s) 48
antiquing 22, 23
chalk coloring 23
crumpling 22
decorative 14, 34, 36, 38, 42, 46, 50, 54, 58, 63, 64, 90, 92, 123, 125
decoupage 14, 66
gluing 24
handmade 96
layering 24
metallic 38, 40
metallic highlights 23
sanding 22
tearing 22
tissue 70, 54, 100, 101, 102, 104, 106, 123
towels 44, 46, 52, 121
washi 74, 125, 126
working with 22
Paperweight 48, 123, 124, 125, 126
Papier-colle 11
Patina, verdigris 21
Pear, foam 70
Pen nib 50
Pencil 38, 40, 66, 70, 116
Petroleum jelly 50
Photo Collage 78
Photo turns 42
Photographs 42, 48, 80, 82, 83, 84, 114
Photomontage 11, 80
Pin back 62
Pin(s) 62, 70, 112, 114
Placemat(s) 82, 83, 84, 85
Plant marker 34
Plate 56
Playing cards 36
Playing the Game Greeting Cards 36
Pliers 61, 70

Poem 66
Point No Point Photomontage 80
Polymer coating 30, 52, 56, 61, 80, 82, 83, 84, 85, 102
Postcards 85, 112
Postcards from Paris Placemat 85
Pots 92
Preparing the Base 20
Pretty Paisley Decorative Box 116
Printer 106
Purse 58
Purse handle 58
Puzzle 38, 40, 44
Puzzle piece(s) 38, 40, 44

Q
Quotation(s) 42, 84, 96, 123, 126

R
Recipes, antiquing & coloring 111
Release agent 121
Renaissance Pears Display Art 70
Resin 48, 121, 123, 124, 125, 126
Resin dome
Rhinestones 58, 119
Ribbon 36, 42, 46, 54, 58, 63, 70, 74, 112, 114, 116
Ribbon, iron-on 110, 119
Rick rack 54
Romance Novel Altered Book 66
Ruler 12, 14, 34, 36, 56, 58, 66, 74, 90, 112
deckle edge 12
decorative edge 14
Rusted Metal 21

S
Sail Day Placemat 84
Sandpaper 50, 54, 56, 74, 102, 121
Scissors 12, 13, 34, 36, 44, 48, 50, 52, 58, 61, 74, 100, 102, 104, 112, 116, 119
decorative edge 12, 13
Seaside Sentiments Paperweight 126
Self-adhesive paper 26
Sewing box 54
Sheet music 76
Shell(s) 96, 126
Sign 88
Silver Sweetheart Pendant Necklace 64
Sisters Framed Collage 114
Spray bottle 100, 101
Sprigs 94
Stamps
postage 85, 123
rubber 50, 88, 90, 96, 101, 102, 104, 106
Starfish 126
Stars 66
Stick, stirring 121
Stickers 15, 25, 34, 36, 38, 42, 44, 46, 48, 50, 52, 54, 58, 66, 70, 76, 96, 102, 123, 125
Sticky note(s) 44
Supplies 12

T
Tag(s) 38, 40, 46, 66, 70, 76, 96, 119
Tape
double-sided 42, 54, 90
masking 76
Tassel 58
Tea bags 22, 56, 111
Tea light 94
Thread 66, 114
Tile(s) 50, 52
Tin 54, 119
Tissue Collage 11
Tissue Paper Collage 98
Tissue paper 70, 54, 100, 101, 102, 104, 106, 123
batik 101, 106
color transfer 100, 102, 104
Tissue, decoupage 70, 92
Toothpick 90
Towel 119
Tracing paper 116
Transfer film 26, 74
Transfer paper
iron-on 110, 114
water-erase 116
Transfer
fabric 110
rub-on 46, 76
Transparencies 25, 26, 27, 28, 44, 46, 50, 56, 84, 90
contact paper 26, 27, 28
Tray 56
Trimmer, paper 12, 13, 42, 46, 80, 106
Turtle 106
Twigs 70

V
Vacation to Remember Photo Frame 102
Varnish
acrylic 29
dimensional 29, 36, 44, 46, 70, 74
matte 44, 46, 54, 74
Verdigris Patina 21
Vials 66
Vintage Photos Placemat 83

W
Washed Metal 21
Watercolors 66
Wax paper 66, 100, 101, 106, 116, 121
Wax
car or carnauba
metallic 38, 40, 74, 76, 88, 90, 96
white 50
Wire 34
Wish You Were Here Vacation Postcards 112
Wood 20
Words *or sayings or lettering* 34, 36, 38, 44, 46, 48, 58, 63, 70, 74, 76, 84, 90, 102
Working with Paper 22